THE ATLANTIC

Edited by
Susanne Østby Sæther, Stefanie Hessler, and Knut Ljøgodt

SKIRA

OCEAN

FOREWORD
Caroline Ugelstad and Susanne Østby Sæther
4

ACROSS AND INTO THE ATLANTIC OCEAN
Stefanie Hessler
6

IN QUEST OF ATLANTIS. THE NORTH ATLANTIC OCEAN AND ITS IMAGES
Knut Ljøgodt
16

WORKS A–D
26

THE ALLURE OF SEAMEN. SAILOR SUITS AND HOMOEROTIC DESIRE IN ART AROUND 1900
Patrik Steorn
60

COASTAL SÁMI AND INDIGENOUS ATLANTIC OCEAN SKILLS
Camilla Brattland and Ove Stødle
68

WORKS E–L
76

ANNA BOBERG'S LOFOTEN PAINTINGS
Martin Olin
102

BUBBLES AS MEDIA IN OCEANIC ECOLOGIES
Melody Jue
110

WORKS M–Z
118

CONTRIBUTOR BIOGRAPHIES
156

FOREWORD

Henie Onstad Kunstsenter is proud to open the exhibition *The Atlantic Ocean. Myths, Art, Science*. With its abyssal depths and immense surfaces, shifting from calm horizon lines to roaring waves, the ocean has fascinated artists for centuries. Its vast expanse has been a projection screen for myths, imaginings, and dreams, a meeting place for science and folklore, fiction and technology, existential quest, and economic expansionism: on the one hand a symbol for romantic longing and drama, on the other an object for explorations of new territories and resources. Presently, the ocean is threatened by acidification, overfishing, and ice melting, and the northern oceans are particularly vulnerable. This international thematic exhibition contextualizes the northern Atlantic Ocean within a historical and contemporary framework by bridging art, myths, and science. Presenting around 140 artworks spanning from the 15th century and until today, the exhibition offers a wide range of visions of the North Atlantic and of how it has shaped human practices, lives, and longings over centuries.

The Atlantic Ocean. Myths, Art, Science is part of a series of cross-disciplinary and research-based exhibitions at Henie Onstad Kunstsenter, in which the art center dives into current themes concerning the relationship between nature and culture in the era of the Anthropocene. With this exhibition we want to underline the importance and the history of the northern Atlantic Ocean in the history of art, to explore how Norway's role as a maritime nation has been seen through the eyes of artists, as well as to shed light on the critical role of the ocean in many of the pressing questions of our time, including climate change, migration, and extraction of natural resources. That the exhibition is officially endorsed as an Ocean Decade Activity by the United Nations Decade of Ocean Science for Sustainable Development 2021-2030 attests to its actuality and relevance.

The Atlantic Ocean. Myths, Art, Science was initiated in 2019 by Henie Onstad's former director, Tone Hansen. In the years through the pandemic, the exhibition has been reprogrammed several times. Working with this exhibition has therefore required flexibility, determination, and creativity on all levels, both by Henie Onstad's own team and from our external collaborators, and Henie Onstad

is extremely grateful for the great effort put in from all the persons involved. The exhibition is curated by Stefanie Hessler, Director of Swiss Institute, New York, and Knut Ljøgodt, Director of Nordic Institute of Art, in collaboration with Henie Onstad's senior curator of photography and new media, Susanne Østby Sæther. We want to extend a huge thank you to Ljøgodt and Hessler for their invaluable expertise, agility and patience through the process.

We thank all the lenders who have generously contributed to the exhibition and for which we are extremely thankful: Archives Jean Painlevé, Paris; Frac Bretagne, Rennes; Nasjonalbiblioteket, Oslo; Malmö Konstmuseum, Malmö; Moderna Museet, Stockholm; Nasjonalmuseet for kunst, arkitektur og design, Oslo; Nationalmuseum, Stockholm; SpareBank 1 Nord-Norges kunststiftelse, Tromsø; Norsk kultursenter, Koppang; Royal Academy of Arts, London; Sparebankstiftelsen, DNB, Oslo; Statens Museum for Kunst, Copenhagen; Stavanger Kunstmuseum, Stavanger; DNV AS, Høvik; Tate Britain, London; TBA21, Vienna; Thorvaldsens Museum, Copenhagen; Victoria & Albert Museum, London; and Örebro Kommun, Örebro. We also thank all lending galleries and private lenders. In addition, we thank all directors, curators, conservators and registrars who we have been in contact with throughout the years and who have shown flexibility and supported the project. We sincerely thank all the artists who have contributed with works to the exhibition, some of which are produced or adapted specifically for it: Kader Attia, Dineo Seshee Bopape, Marjolijn Dijkman, Matías Duville, Marie Kølbæk Iversen, Toril Johannessen, Joan Jonas, Jessie Kleemann, Armin Linke, Eline Mugaas, Joar Nango, Trevor Paglen, Sondra Perry, Fin Serck-Hanssen, Himali Singh Soin, David Soin Tappeser, Susanne M. Winterling, and David Zink Yi.

The catalogue is generously supported by the Fritt Ord Foundation. Furthemore, we thank the contributors to the catalogue: Camilla Brattland, Melody Jue, Martin Olin, Patrik Steorn, and Ove Stødle, who in addition to Hessler and Ljøgodt have contributed with new texts.

Henie Onstad Kunstsenter expresses sincere gratitude to the institution's main sponsors and supporters: DNV, Sparebankstiftelsen DNB, ABG Sundal Collier and Reitan Retail. In addition, we are grateful for the support provided specifically for this exhibition by Nadia og Jacob Stolt-Nielsen Veldedige Stiftelse, Formue, Blystad Group, Clarksons, Viking, Bergesenstiftelsen, and those that wish to remain anonymous.

Caroline Ugelstad
Director of exhibitions
and collections

Susanne Østby Sæther
Senior curator of photography
and new media

ACROSS AND INTO THE ATLANTIC OCEAN

Stefanie Hessler

A hollow vessel made from horn, small enough to be held in one's hand, sits atop a mirrored surface. No larger than the size of a fingertip, the shape is reminiscent of that of a ship. It carries a figure made from an abstract fragment of ironwood over a calm body of water, or perhaps over a sheet of ice. Artist Iver Jåks (1932–2007) titled his sculpture *Liten Háldi* (*Little Háldi*) (1996) → FIG. A in reference to a spiritual being in Sámi mythology, possibly a guardian, who travels by boat. In the work, two materials are wedded, while the mirror suggests a meeting between physical and spiritual worlds, between the here and now and an otherwise past or future. Combining *duodji* (Sámi craft) with modernist visual language, Jåks's sculpture contains relational qualities: it can be kept in one's pocket as an amulet, or passed on to a friend. As artist niilas helander writes in reference to *Liten Háldi*: "Sámi relate to land and nature as a physical and spiritual unity. The philosophy and way of life is based on a mutual relationship with everything in the outside world."[1] This includes *siedier*, or relatives, which can be found in specific rock formations, fishing sites in the sea, or wooden figures made by people. In this philosophy, relatives are neither limited to humans, nor to the present, but they encompass numerous nonhumans, both physical and spiritual, including the ocean.

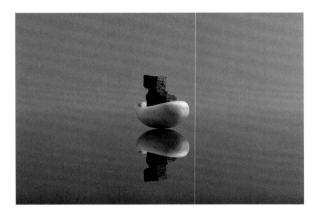

FIG. A Iver Jåks, *Little Háldi*, 1996.
Photo: KORO/Guri Dahl.
© Iver Jåks/BONO 2024.

Jåks's sculpture suggests fluidity and defies fixity of relations and meaning. It points to the richness of the ocean as a space in which matter and spirit coalesce, and where ecology, mythology, and culture flow together. *Liten Háldi*, unassuming in scale as it may be, opens the exhibition *The Atlantic Ocean. Myths, Art, Science* at Henie Onstad Kunstsenter to the currents of exchange and trade past and present crossing the Atlantic, the majestic and miniscule lifeforms traversing its depths, the changes it undergoes due to climate change, and issues of geopolitics, economics, and extraction, as well as labor, leisure, and migration.

The Atlantic is the second largest of the planet's five oceans, after the Pacific and followed by the Indian, Southern, and Arctic Oceans. It connects Africa, South and North America, and Europe, is home to countless ecosystems, cultures of

people living along its coasts and nomadically on its surface, and histories of both horror and beauty. The Atlantic is a hotspot of climate change, with its northern regions warming faster than a lot of other ocean areas, and the Arctic, in particular, having warmed four times faster than other parts of the planet in the years since 1979.[2] In addition to the ecological and humane disasters warming temperatures are already causing, they will also affect geopolitics and economics. The Northeast Passage, a shipping route connecting the Atlantic with the Arctic Sea including the Barents, East Siberian, and Chukchi Seas all the way to Alaska in the east, is anticipated to open up for longer periods during the summer, changing trade routes and causing a new clamber for influence in the north. The Polar Silk Road, part of China's broader Belt and Road Initiative, is another such maritime project. Initiated in 2018, it is aimed at establishing new shipping passages in the far north as ice is melting, and promises to impact trade dynamics while also raising concerns regarding the Arctic's fragile ecosystem.

MYTHS, VISIONS, AND THE SENSORIUM

The Atlantic Ocean has been subject to artists' interest for centuries. In the exhibition at Henie Onstad Kunstsenter, a wide range of works, spanning from 1482 to 2024, engage changing attitudes and understandings, interconnected topics and geographies as well as media from painting to digital animation, sculpture and sound installations to early experiments with photographic and filmic representations that, for the first time, made visible the hitherto hidden aquatic dimensions for wide audiences. One of the most celebrated artists literally diving into the ocean to make his work as well as filming in aquariums was the photographer and filmmaker Jean Painlevé (1902–1989). Fascinated with the minutiae and microscopic details of underwater worlds, Painlevé's images embody both scientific research and surrealist enchantment. Having first studied medicine and later marine biology, Painlevé's interest in science and anatomy, as well as his friendships with artist Alexander Calder, playwright Jacques Prévert, and filmmakers like Sergei Eisenstein and Luis Buñuel, influenced his aesthetic choices. Among his most beloved films is *The Octopus* (1928), following the sea creature as it slithers over rocks, sand, and—in surrealist fashion—a human skull, with a title card informing viewers of hue changes enabled through the contraction and dilatation of color cells in its skin. What Painlevé thought of as phenomenological similarity between his photograph *Lobster Claw* (1931) → FIG. B and Charles de Gaulle led him to rename the picture in 1945 in reference to the French president. The anthropomorphism in Painlevé's works evoked empathic responses for these seemingly otherworldly creatures in his audiences.

The ocean's alien fascination as well as its mythology continue to inform contemporary artists' work. Joan Jonas, the groundbreaking artist bridging performance with moving image and installation, has been incorporating footage by Painlevé in her work, combining it with literary sources from Shakespeare to T. S. Eliot, Anna Akhmatova, and Rachel Carson. In Carson's famous essay "Undersea" from 1937 the marine biologist asks, "Who has known the ocean?" She goes on to answer it by pointing out our perceptive limitations:

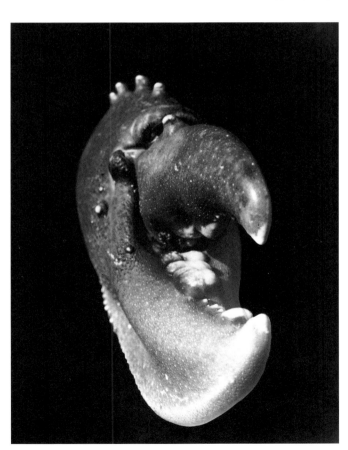

FIG. B Jean Painlevé, *Lobster Claw or de Gaulle*, 1931. Silver gelatine print. Courtesy Archives Jean Painlevé/Les Documents cinématographiques, Paris. © Jean Painlevé/BONO 2024.

Neither you nor I, with our earth-bound senses, know the foam and surge of the tide that beats over the crab hiding under the seaweed of his tidepool home; or the lilt of the long, slow swells of mid-ocean, where shoals of wandering fish prey and are preyed upon, and the dolphin breaks the waves to breathe the upper atmosphere.[3]

In her performance *Moving Off the Land* (2016–2018) → FIG. C, Jonas references Carson as she immerses audiences in the metaphoric oceanic space from whence humans evolved and the saltine memory we continue to hold in our bodies. Combining underwater videos shot by the artist in the Lofoten Aquarium, as well as in aquariums in Boston, New York, and Mystic, among other locales on the east coast of the United States and in the Caribbean Sea of the Atlantic Ocean, with scientific footage by marine biologist David Gruber, props from performances, sound, and drawings, Jonas explores the ocean as a mythological, ecological, and political space. Shown in the exhibition is a series of reproductions of drawings of fish → FIGS. 49–52 installed above the audience's heads as they enter, or descend, into the metaphorical Atlantic at Henie Onstad Kunstsenter.

Similarly interested in the ocean as a space engaging the entire sensorium, Matías Duville's large-scale drawings emerge from his experience as a surfer, or what geographers Leah Maree Gibbs and Andrew T. Warren call the embodied knowledge of ocean users, which, although often discredited by Western science, offers important epistemological value.[4] Duville's drawings → FIGS. 40, 41 explore notions of the sublime and its close associations with the ocean from the Romantic period to today. Most Romantic painters only knew of the North Atlantic as an idea and as an ideal, not as a real place. J. M. W. Turner painted by the south coast of England, but there were few, among them Norwegian artist Peder Balke, whom Knut Ljøgodt writes about in his essay, who undertook a voyage to the northernmost reaches. Duville, while exploring the contemporary sublime, goes beyond observation as an onlooker and immerses himself in the ocean to inform his work.

FIG. C Joan Jonas, *Moving Off the Land*, 2016–2018, performance at Danspace, New York, NY, 2018. Photo: Ian Douglas. © Joan Jonas/BONO 2024.

EXPLORATIONS ACROSS CARTOGRAPHY AND SCIENCE

While Rachel Carson pointed out the limitations of our knowledge of the ocean with our earth-bound senses, efforts to study it often equate attempts at controlling it, which intensified with early ocean exploration and continues through today. Presented in the exhibition are early maps like Olaus Magnus's *Carta Marina* (1539) or Abraham Ortelius's *Islandia* (1592), teeming with sea monsters, which were issued as warnings to sailors and simultaneously lured seafarers to faraway shores with their unknown riches. The allure of oceanic myths is mirrored in David Zink Yi's *Untitled (Architeuthis)* (2010) → FIG. 110. The intricately glazed ceramic sculpture in the shape of a giant deep-sea squid materializes what was long thought to be a fabled creature. Surrounded by Chinese ink and syrup, the liquid also brings to mind oil spills from offshore drilling operations.

The earliest physiographic map of the North Atlantic ocean floor was pub-

lished in 1957 by geologists and oceanic cartographers Marie Tharp and Bruce Heezen of the Lamont Geological Observatory at Columbia University. Tharp was one of the first female oceanographers, and the initial scientist to suggest the existence of the 10,000-mile-long Mid-Atlantic Ridge, which forms part of the largest mountain range on Earth, separating the Eurasian and African Plates from the North American Plate. Susanne M. Winterling's installation in the exhibition pays homage to Tharp's findings and legacy for oceanic cartography, while calling attention to the gendered bias in science → FIG. 109. Tharp was not allowed on the ships that collected the data she used to make her maps until 1968, and even though her findings introduced a paradigm shift that established plate tectonics and continental drift, her revolutionary discovery was initially dismissed as "girl talk."[5] A reading of Martin Olin's text on painter Anna Boberg in this book, who created stunning images of the Lofoten Islands → FIGS. 30, 31, and her reluctant recognition in the Swedish canon due to her work being considered too removed from the artistic ideals of the Artists' Association, offers thought-provoking parallels to this all-too-common story.

Aside from scientific study, ocean exploration was and still is often fueled by geopolitical and economic interests. Marie Kølbæk Iversen's video work and sculptures titled *Rovhistorier* (*Histories of Predation*) (2022) → FIGS. 46, 47, are based in the artist's research on the Greenland shark, a fish species that can live for over 500 years. The shark was severely overfished in the early 1900s for its liver oil, which was utilized as machine oil during wars. Even prior, since the 13th century, the oil was valued for its use in lamps. Distributed across the North Atlantic, in Kølbæk Iversen's work the shark also serves as a metaphor for the colonization of Greenland through Denmark-Norway, which the artist places in relation to the colonization of nature. The sculptures are casts of parts of the shark. A three-channel video installation accompanies the sculptures, composed of Kølbæk Iversen's research in collaboration with Jonathan R. Brewer from the Danish Molecular Biomedical Imaging Center at the University of Southern Denmark and marine biologist Julius Nielsen, then working at the Greenland Institute of Natural Resources. Nielsen's research enabled the determination of the Greenland shark's longevity through carbon-14 dating of crystals from its eye lenses.

For Marjolijn Dijkman and Toril Johannessen's installation *Liquid Properties* (2018) → FIG. 38, the artists collected brackish water from the fjord near Oslo. Placed in rounded glass globes housed in a metal scaffolding, the work brings to mind the lenses in Kølbæk Iversen's work as well as Melody Jue's exploration of bubbles as oceanic media in her text featured in this book. The artists explore the aesthetics of science and the paradigms of mediated vision, much of which is at stake in ocean exploration through cameras, see Painlevé, as well as remotely operated submarines. *Reclaiming Vision* (2018) → FIG. 39, the video accompanying the installation, homes in on the tiny nonhumans living in the Oslo fjord, and, in reference to philosopher Jane Bennett, their vibrant materiality, as well as the aesthetics and paradigms of science, where the work suggests enriching the quest for positivist objectivity with relational entanglement.[6]

TRADE, MILITARIZATION, AND EXTRACTION

The impact of fishing, trade, and an increasing infrastructuralization of land and water, or what architectural theorist Keller Easterling calls "extrastatecraft," creates a new spatial yet largely invisible matrix of state and non-state actors laying claim to resources.[7] Aptly, artist and theorist Allan Sekula (1951–2013) has called the

ocean the forgotten space. For his influential work *Fish Story* (1989–95) → FIG. D, Sekula → FIGS. 94-100 documented oceanic container trade, which today accounts for 90% of the world's commerce, at a moment when the "doctrine of free trade"[8] was on the rise. Through photography and writing in a methodology he referred to as "critical realism," Sekula documented labor in ports and on container ships, as well as the infrastructures producing levels of abstraction in which we no longer smell or touch the ocean, but where goods are put away inside containers, apparently fulfilling the modernist promise of abstracted flows of capital. The anonymity of these boxes followed the development of steam-powered vessels in the late 18th century, replacing sailboats and their errant routes. It is no wonder, then, that J. M. W. Turner was painting his Romantic seascapes depicting the sublime forces of the ocean at a time when those forces appeared to lose their influence over human destiny.

Trevor Paglen's photographs → FIGS. 84, 85 similarly pinpoint how the oceans are subjected to various levels of abstraction, or, in this case, more purposeful obfuscation. In the aftermath of the United States National Security Agency (NSA) surveillance scandal exposed by Edward Snowden in 2013, Paglen organized diving trips to the sub-Atlantic cables the agency had tapped. These cables, the first version of which was laid by the Atlantic Telegraph Company in 1858, form the basis for today's electronic communications networks of the internet, connecting servers around the planet. The digital age is propped up by these very physical infrastructures, and the Atlantic, especially towards the High North and the Arctic, is a geopolitically and commercially strategically important region undergoing increasing militarization.

Armin Linke's long-term research project culminating with the multimedia installation *Prospecting Ocean* (2018) → FIGS. 62-68 continues the legacy of Sekula's work. For several years, Linke visited international institutions that are tasked with the administration of the oceans to bring attention to the new threat of deep-sea mining. Enmeshed in a complex web of legal frameworks and political-economic intentions similar to those Easterling describes in her book, companies partner with nation states to begin exploiting minerals that have formed over millennia near hydrothermal vents at the ocean floor. The Azores islands in the Atlantic are one area of particular interest, alongside the Clarion-Clipperton Zone in the Pacific and other locales. Linke documents the entanglements of science, intergovernmental agencies such as the United Nation's International Seabed Authority, and industry pushing towards ocean extraction. The Norwegian University of Science and Technology in Trondheim is among the sites Linke visited and photographed. Here, scientists and engineers work on novel forms of research and technology including underwater hyperspectral imaging to map the seafloor and identify different types of minerals, as well as advance vehicle and platform development with the aim of mining. In January 2024, as of the writing of this text, Norway's parliament voted to open up for deep-sea mining, making it potentially the first country in the world to commercially exploit the seabed in its national waters. The risks of deep-sea exploitation are manifold and the impact of mineral extraction on ecosystems not well understood, making this scramble for resources a particularly dangerous new frontier.

Since Norway issued its first licenses to explore, drill, and exploit oil and gas in 1965, to the discovery of the first oil field, Balder, two years later, and the beginning of oil extraction in 1971, offshore oil production has deeply changed

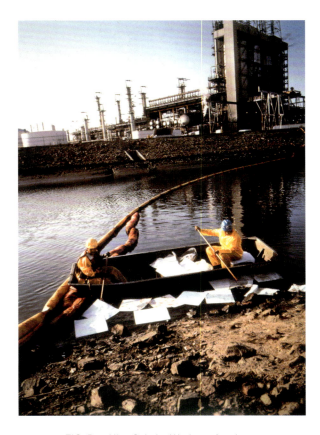

FIG. D Allan Sekula, *Workers cleaning up chemical spill after refinery explosion. Los Angeles harbour. Wilmington, California*, of the whole *Fish Story (Chapter I, Fish Story)*, October 1992. Frac Bretagne Collection © The Estate of Allan Sekula. Photo: Frac Bretagne.

the country's economy and culture. For his series *Pionérdykkerne fra Nordsjøen* (*Pioneer Divers from the North Sea*) (2006) → FIGS. 101, 102, Fin Serck-Hanssen photographed and interviewed pioneer divers who worked on the platforms, and while they made Norway's Janus-faced oil revolution happen, they have hardly been acknowledged. For the exploration of Ekofisk, one of the largest offshore oil fields ever identified, and other new discoveries, divers needed to descend further than many of the pioneers had previously gone in Mexico or the British offshore oil sector—going down to 80 meters and below. The climate and working conditions were harsh, with many risks involved that turned each dive into a precarious experiment.[9] Combined with gross negligence on the part of the authorities, accidents—dozens of which were fatal—were common, and so were suicide rates in desperation as divers were stripped of certificates of injury and without any follow-up or healthcare. As Hildegunn Birkeland, Jan Rustad, and Fin Serck-Hanssen write in their introduction to Serck-Hanssen's exhibition in Stavanger in 2006, "the oil was going to come up no matter how many divers died."[10] In the series, Serck-Hanssen pairs portraits of the divers with accounts of their experiences, among them Tom Engh and Rolf Guttorm Engebretsen recounting a disastrous diving accident leaving Engh clinically dead and, after he was revived, in what he describes as a "foggy state" for fifteen years, none of which either the oil or the diving companies ever acknowledged responsibility for.

In 2006, Eline Mugaas took photographs of the deck of a Norwegian oil tanker in the North Sea, which are shown publicly for the first time in the exhibition → FIGS. 75–78. Highlighting the role oil plays for the national economy, Mugaas's photographs are also a study of the architectural topographies of the infrastructures of extraction as well as of her experiences aboard the vessels. Mugaas's prints call to mind the typological studies of photographers Bernd and Hilla Becher, who documented industrial architectures in Germany and Western Europe in the second half of the 20th century, when these were quickly disappearing. Mugaas's work records the naval architectures and technologies not as they are vanishing, but as they are continuing to proliferate off the Norwegian shoreline.

INDIGENOUS TECHNOLOGIES AND FEMINISMS

Dedicated to another type of building is Joar Nango's installation *Skievvar* (2019–) → FIGS. 80, 81. Nango has been working on revitalizing and defining Sámi architecture, both past and present as well as how it might evolve in the future. Nango's project unravels the colonial aspects of architecture, through settlers moving into and building on Indigenous land, and brings attention to nomadic native houses such as the *lavvu* cone-shaped tent structures. In his installation at Henie Onstad Kunstsenter, Nango uses dried halibut skin as an Indigenous technology in the traditional way it has been stretched in wooden frames and used as windows thanks to its translucency and insulating properties.

Kalaaleq artist Jessie Kleemann's work is informed by Indigenous feminism, and in particular her Greenlandic heritage. Her performances evoke Arctic landscapes through movement, voice, and unmediated, fast paintings onto elongated scrolls of paper. Kleemann often invokes spiritual figures, such as the Inuit goddess of the sea, merging wisdoms transmitted through generations via mythology with warnings of the fragile Arctic ecologies that human actions are destroying, and decolonial resistance. The late Kalaaleq and Danish artist Pia Arke (1958–2007), born in Scoresbysund or Ittoqqortoormiit, worked through painting, photography, video, performance, and sculpture to critique Danish colonialism in

Greenland and how it changed social relations as well as people's connections with the environment. Her essay *Etnoæstetik (Ethno-Aesthetics)* (1995) critiques the romantization and exotification of Inuit culture measured and posited against a Western paradigm. Arke writes:

> *So the ethnic condition is in truth ironic: on the one hand, by our own example, we are a necessary, external contribution to the European self-view; on the other hand, owing to this very self-view, we do not quite match European superiority, and must generally remain a sadly outdistanced supplement, an unbearable reminder of the ethnic, the political, the economic—in short, of everything 'un-aesthetic' about aesthetics.*[11]

TRANSATLANTIC SLAVE TRADE AND CONTEMPORARY MIGRATION

While the exhibition largely focuses on the North Atlantic, the oceans' waters are hardly containable, and flows of capital and routes of people connect, if unevenly, across continents. In 1974, divers discovered the sunken slave ship Fredensborg, built in 1753 in Copenhagen at a time when Denmark-Norway was joined in the "twin-kingdoms." In 1767 the ship crossed between the Gold Coast in Ghana with 265 captives to St. Croix, where 235 surviving people were disembarked. On December 1, 1768, it sank in a storm near Arendal. Relating another corresponding incident, Sondra Perry's installation *Wet and Wavy Looks — Typhoon coming on for a Three Monitor Workstation* (2016) → FIG. E addresses a scene depicted in Turner's famous painting *Slave Ship (Slavers Throwing Overboard the Dead and Dying, Typhoon Coming On)* from 1840, of 133 enslaved people who were thrown into the Atlantic by the captain of the Zhong, a British slave ship, to receive insurance compensation. Perry's work consists of a rowing machine filled with blue Eco styler hair gel popular for the strong hold it offers curly hair. Installed in the front of Perry's workstation are three monitors featuring a digitally manipulated animation of Turner's famous painting. The work is sonified by Missy Elliot's 1997 debut solo single *The Rain (Supa Dupa Fly)*. In Perry's installation, it references not only a storm, but the tempest of what literature scholar Christina Sharpe calls the all-surrounding weather of anti-Blackness in the United States and internationally. Sharpe expands this meteorological notion to critique cultural, political, and sociological environments perpetuating racial and colonialist systems in the wake of the transatlantic slave trade.[12]

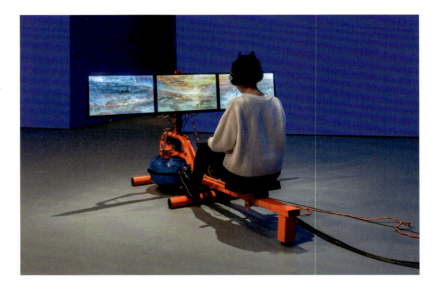

FIG. E Sondra Perry, *Wet and Wavy Looks — Typhoon coming on for a Three Monitor Workstation*, 2016. Video, rowing machine workstation, Eco styler gel. Courtesy the artist and Bridget Donahue, NYC. Photo: Jason Mandella.

Dineo Seshee Bopape's three-channel video installation *Lerato laka le a phela le a phela le a phela/My love is alive, is alive, is alive* (2022) → FIGS. 32, 33 "pays homage," in the artist's words,

> *to the ocean as a host of memories: of Peter and 12 million others who crossed the Atlantic, those who survived and those who fled in the waters escaping enslavement, seeking sanctuary amid the water.*[13]

Filmed in Louisiana on the Gulf of Mexico—a marginal sea of the Atlantic—Jamaica in the Caribbean Sea of the Atlantic, as well as South Africa and West Africa, these locales are connected through slavery, but also the trade of codfish, which is crucial to the history of Norway and the North Atlantic. In order to feed enslaved people brought to the Caribbean from West Africa by Europeans to work on sugar cane plantations, owners sought cheap alternatives to turning large areas of their estates into land for crop or animals. Instead, they bought low grade salt cod from New England merchants, soon linking molasses, salt cod, and the trade of enslaved people in insidious ways.[14] In Bopape's video, she tests the ocean as an incomplete and ephemeral, queer, archive of feeling of remembering as much as of forgetting, as gender and environmental humanities scholar Astrida Neimanis suggests.[15]

While slavery has contributed significantly to the economic development of Europe and the Americas, the wealth amassed through racial systems of exploitation has left a cleavage of economic disparities and disenfranchisement, including persistent inequalities in economic prosperity, health, and opportunity. Kader Attia's photographs in the exhibition depict young people sitting on concrete blocks that resemble modernist architecture in the suburbs of European cities, facing the sea and looking out across its expanse. The photographs capture the longing of migrants who continue to take on arduous journeys in hope for a better life, but are often met with death or a dream-crushing reality of detention centers and deportation. Whereas Attia's *Rochers Carrés* (2008) → FIGS. 15-18 series was photographed in Algiers, in recent years increasing border controls of Mediterranean routes of migration to Europe have led to an uptick in travel on the extremely dangerous passage to the Spanish Canary Islands off the Atlantic coast of West Africa.

Casting a wide web of relations, *The Atlantic Ocean. Myths, Art, Science* crosses history and the present of the Atlantic, bridging migration and politics, ecology and mythology, labor and extraction. Bringing together historic works with contemporary positions, the exhibition dives into the Atlantic as a space where relations are continuously negotiated, where distant geographies flow together, where cultures meet and futures are shaped.

Endnotes

1 "Det samiska förhåller sig till marken och naturen som en fysisk andlig enhet. Filosofin och levnadssättet bygger på ett ömsesidigt förhållande till allt i omvärlden." Translation by the author. niilas helander, "Iver Jåks Utvidgade Relationer," in *Paletten*, vol. 310–311, 2018, p. 7.

2 Mika Rantanen et al., "The Arctic has warmed nearly four times faster than the globe since 1979," in *Communications Earth & Environment*, vol. 3, no. 168, 2022, np.

3 Rachel Carson, "Undersea," in *The Atlantic*, September 1937, https://www.theatlantic.com/magazine/archive/1937/09/undersea/652922/ (accessed 5 January 2024).

4 Leah Maree Gibbs and Andrew T. Warren, "Transforming Shark Hazard Policy: Learning from ocean-users and shark encounter in Western Australia," in *Marine Policy*, vol. 58, August 2015, pp. 116–124.

5 Columbia Climate School Lamont-Doherty Earth Observatory, *About Marie Tharp* [website], https://marietharp.ldeo.columbia.edu/about-marie-tharp (accessed 5 January 2024).

6 Jane Bennett, *Vibrant Matter: A Political Ecology of Things*. Durham, NC and London: Duke University Press, 2010.

7 Keller Easterling, *Extrastatecraft: The Power of Infrastructure Space*. New York, NY: Verso, 2014.

8 Allan Sekula, *Fish Story*. Düsseldorf: Richter Verlag, 2002, p. 44.

9 "For opp skulle oljen uansett hvor mange dykkere som døde." Translation by the author. Fin Serck-Hanssen, *Pionérdykkerne fra Nordsjøen*. Stavanger: Sølvberget, 2006, np.

10 Ibid., 8.

11 Pia Arke, "Ethno-Aesthetics," in *Afterall: A Journal of Art, Context and Enquiry*, vol. 44, Autumn/Winter 2017, p. 9.

12 Christina Sharpe, *In the Wake. On Blackness and Being*. Durham, NC: Duke University Press, 2016.

13 *Contemporary And*, Museum of Modern Art: *Projects: Dineo Seshee Bopape* [website], https://contemporaryand.com/fr/exhibition/projects-dineo-seshee-bopape/ (accessed 28 December 2023).

14 Mark Kurlanksy, *Cod. A Biography of the Fish That Changed the World*. London and New York, NY: Penguin Books, 1997.

15 Astrida Neimanis, "Water, a Queer Archive of Feeling," in Stefanie Hessler (ed.), *Tidalectics. Imagining an Oceanic Worldview through Art and Science*. London and Cambridge, MA: TBA21–Academy and The MIT Press, 2018, pp. 189–198.

IN QUEST OF ATLANTIS. THE NORTH ATLANTIC OCEAN AND ITS IMAGES

Knut Ljøgodt

Atlantis—the mythical island first mentioned by the Greek philosopher Plato and which gave its name to the Atlantic Ocean—was allegedly situated outside the Strait of Gibraltar (also called the Pillars of Hercules).[1] The island was named after Atlas, son of the sea god Poseidon and forefather of its inhabitants, the so-called *Atlantians*. Once a great empire, the island sunk according to legend into the sea. For more than two millennia, mankind has searched for and been fascinated by this lost civilization—or rather, the idea of it. Today, it still captures the imagination of contemporary artists as well as popular culture.

With the explorations and expeditions in the 16th and 17th centuries, the myth gained new interest. The German Jesuit Athanasius Kircher, for instance, placed Atlantis as a continent of its own in the Atlantic Ocean between "Africa" and "Hispania" on the one side and "America" on the other → FIG. F. For the explorers and their chroniclers, the quest for this long-lost world could symbolize the search for new and "undiscovered" continents—whether the Americas or the Arctic—while for humanist writers of the renaissance, Atlantis came to represent the ideal of a utopian civilization. An outstanding example was the Swedish scholar Olof Rudbeck (1630–1702), who based his *Atlantica* (*Atland eller Manheim*, published in four volumes 1679–1702) → FIG. G, on ancient Greek and Latin as well as Norse sources, combined with his own reflections on history and natural conditions. According to Rudbeck, Atlantis was—somewhat surprisingly—to be found in the North, on the Scandinavian peninsula, more specifically in Upsala in Sweden:

> *[...] I came to the shores where Aspen groves*
> *are full of golden apples, where the sprite rules the ocean*
> *and lets no one pass to sail the seas*
> *where earth and sky have their end*
> *whose turning point Atle holds – where*
> *the Maelstrom is the source of all oceans,*
> *where Thor has his seat [...]*[2]

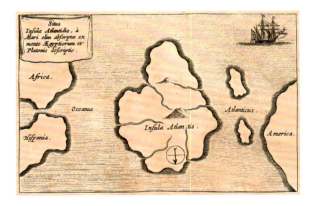

FIG. F Athanasius Kircher, *Map of Atlantis*. From *Mundus Subterraneus*, Amsterdam 1669. Public domain.

To argue his case, Rudbeck interpreted the sources rather freely, inserting references to Nordic mythology and topography. Atlas, for instance, became the Norse Atle. This was written during Sweden's heydays as a great power, and by situating Atlantis there, the author is able to present his native country as the cradle of Europe's civilization. We may describe this as an act of revisionist history writing with a national-political agenda. Even if Rudbeck's theories are long since discarded, and few seem to believe in the existence of Atlantis anymore, the changing attitudes to this mythical place in many ways reflect how the ocean that bears it name has been perceived through the centuries. The Atlantic Ocean continues to fascinate. Especially for those of us who live by its shores—including its Northernmost parts here in Scandinavia—the Atlantic has always played a central part. In many ways, it has defined our everyday lives as well as our history. The ocean has been an ore for transportation and has been perceived as a treasure trove for natural resources and commerce, thus representing opportunities and prosperity but eventually also leading to exploitation. In addition, the sea has been seen as representing strong forces, taking the lives of many people, and has been associated with danger and even mystery. This is also reflected in how the Atlantic has been imagined in art and literature through the ages.

THE PERILOUS SEA: IMAGES OF THE ATLANTIC OCEAN

Some early modern depictions of the Atlantic Ocean are to be found in maps from the 16th and 17th centuries.[3] Often, these emphasize the threatening aspect of the sea as a place of unknown forces. Already Odysseus was attacked by creatures such as Scylla and Charybdis during his voyages as sea, according to Homer. Particularly, these ideas have been associated with the North-Eastern parts of the Atlantic as well as with the Arctic. This region has from ancient times onwards been known as *Ultima Thule*; Thule the end of the world.[4] In Olaus Magnus's *Carta Marina* (Venice 1539 and later editions) → FIG. 71—one of the earliest known maps of Scandinavia—the sea surrounding an island named "Tile" and the rest of the Nordic region is inhabited by strange creatures: giant fish, sea serpents and other monsters. The different creatures may have had an allegorical function.[5] Olaus Magnus (1490–1557) was a Swedish Catholic archbishop who had settled in Rome after the reformation. Even his *Historia de gentibus septentrionalibus* (*History of the Nordic People*, 1555) deals with sea serpents and other strange creatures. It also includes depictions of the customs of the people as well as natural phenomena, including the Maelstrom → FIG. 72.

In the first map of the Arctic, published by Willem Barentsz (Amsterdam 1598 and later editions) → FIG. 23, monster-like creatures again appear in the sea. The Dutch seafarer Willem Barentsz (1550–1597) led three expeditions to the Arctic Seas during the late 16th century. The purpose was to trace the North-East Passage and establish a new trading route to Asia. Producing a map that showcased all the dangers of the sea could be an efficient method to tell competitors to keep out. The different expeditions opened the nature of the Arctic Sea up to exploit its resources, including extensive whaling. Whales were hunted mainly for oil, which was primarily used in lamps. Stations to extract oil were established on Spitzbergen → FIG. H. In the 19th and 20th century, whaling became more industrialized → FIG. 45, while still surrounded by a kind of mysterious Romanticism as expressed in Herman Melville's

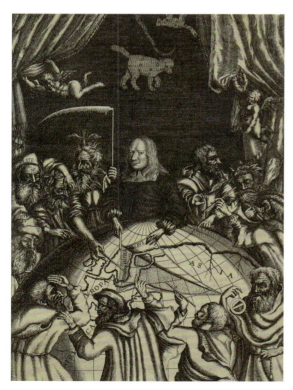

FIG. G Olof Rudbeck, surrounded by ancient philosophers and mythical figures, reveals the location of Atlantis, 1689. From Rudbeck's *Atlantica*, Uppsala 1679–1702. Göteborgs universitetsbibliotek, Litterturbanken.

IN QUEST OF ATLANTIS

novel *Moby Dick* (1851): "[...] the overwhelming idea of the great whale itself. Such a portentous and mysterious monster roused all my curiosity. The wild and distant seas where he rolled his island bulk; the undeliverable, nameless perils of the whale [...]".[6] Nevertheless, whaling was essentially about exploring natural resources, like today's industrial activities in the sea.

Humanity's irreversible footprints in the Arctic nature—recognized fully only today—are often traced back to the Industrial Revolution, but we may with some right claim that this development in fact started in the wake of the early expeditions and explorations in the 16th and 17th centuries.

The idea that the ocean is inhabited by sea monsters, mermaids and other creatures is found in the folklore of most people living close to a seashore. It was given credibility through the visualization of the early mapmakers and even the writings of scientists. As late as the 1750s, the Danish scholar and theologian Erik Pontoppidan (1698–1764) dealt with sea serpents, mermaids and the *kraken* in his two-volume work *The Natural History of Norway* → FIG. 90.

In Norway, few artists did more to visualize the country's folklore than Theodor Kittelsen (1857–1914). A stay in Lofoten in the 1880s gave him inspiration to depict the region's nature as well as its mythical creatures.[7] His different drawings of sea-trolls and *The Draug*—the ghost of a dead sailor hunting for other humans to drag into the sea—are of a particular chilling character → FIG. 54. Another artist fascinated by the sea's mythical universe was the-turn-of-the-century artist Frida Hansen (1855–1931); a Scandinavian pioneer of the *art nouveau* movement.[8] A recurring subject in her tapestries was mermaids, which she depicted with a somewhat poetical interpretation → FIG. 44.

This demonstrates how the mythological universe associated with the ocean continued to hold its sway over artists and writers for centuries, whether we talk about the ancient legend of Atlantis or the mythical creatures found in the works of *fin de siècle* artists like Hansen and Kittelsen. Even today, artists such as Joan Jonas and David Zink Yi find inspiration in the mythical creatures of the sea → FIGS. 42–52, 110.

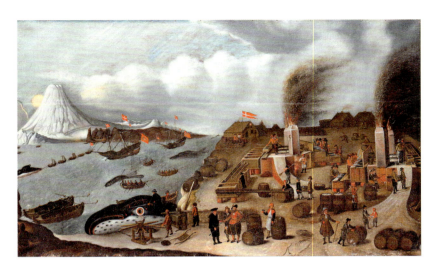

FIG. H Abraham Speeck, *Whaling on Danes Island, Spitzbergen*, 1634. Oil on canvas, Skoklosters slott, Stockholm, public domain. Photo: Jens Mohr.

THE SUBLIME ATLANTIC: SHIPWRECKS AND STORMY WEATHER

During the Romantic movement of the early 19th century, the grand and dangerous element of nature came to play an increasingly central part in art and literature. This must be seen on the background of the period's interest in the Sublime, established as an aesthetic category by the philosopher Edmund Burke around the middle of the 18th century. The sublime, according to Burke, is what overwhelms us and creates awe—whatever excites "the ideas of pain, and danger, whatever is in sort terrible [...] is a source of the sublime."[9] For the Romantics and their predecessors, human emotions were of particular importance. Especially, fear was well suited to stir the emotions. Let us bear in mind that it was in parallel to the emergence of the Sublime that the Gothic novel was established as a literary genre. While both supernatural creatures and human cruelty were preferred elements in early horror fiction, even nature could play a part to this effect.

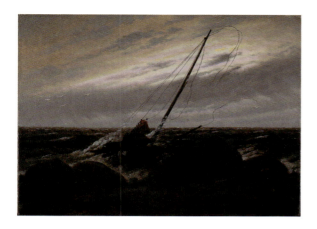

FIG. I Caspar David Friedrich, *After the Storm*, 1817. Oil on canvas SMK – Statens Museum for Kunst, Copenhagen.

In Romantic painting, the sea soon became a recurring subject. Of course, maritime painting was in no way a new genre, but the beginning of the 19th century saw a cultivating of especially dramatic scenes of sea at storm. Different artists—such as J. M. W. Turner, Eugène Delacroix, Thomas Cole and J. C. Dahl—painted the sea, often with a ship caught in a storm or a shipwreck.[10] The Romantic mind was preoccupied with the struggle between the human being against the overwhelming forces of nature. Especially the German Romantics cultivated a particular form of nature mysticism, well-known from the works of Caspar David Friedrich (1774–1840). His paintings sometimes show dramatic shipwrecks in a storm → FIG. I, at other times contemplative, melancholy night scenes. A similar sensibility is reflected in *Night piece, from the closing scene of "René" by Chateaubriand* (early 1800s) → FIG. 34 by Franz Ludwig Catel (1778–1856), another German artist. Such paintings represent what is known as the *transcendental* current within the Romantic movement. Nature represents something larger than itself—a spiritual dimension or a world-soul—which the Sublime and mysterious elements in a landscape communicate to us. This idea is often expressed in Romantic poetry through a yearning for eternity. It is also formulated in the writings of Carl Gustav Carus—a painter and scientist belonging to the circle of Friedrich and Dahl—in his *Nine Letters on Landscape Painting* (1831): "The direct surrender of nature to the supreme absolute, which is its fountainhead, is what we call religion (brotherly communion, unification)."[11]

The Norwegian artist Johan Christian Dahl (1788–1857) settled in Dresden, becoming a professor at the Art Academy and a friend of Friedrich and other German artists and intellectuals of the time.[12] Regularly making journeys back to Norway, Dahl made its his mission to depict the nature of his native country: mountains and valleys, as well as sea and coast. The shipwreck became a recurring motif in Dahl's *oeuvre*; reflecting his background in the European Romantic movement. In *Shipwreck by the Coast of Norway* (1830) → FIG. 37, the storm has calmed, and a vessel has found refuge among the cliffs on the West Coast of Norway, close to Dahl's native Bergen. While some of the other Romantic painters would emphasize the dramatic or the mysterious, Dahl's depiction is more sober and naturalist, while at the same time even this scene reminds us of mankind's struggle against the strong forces of nature. A more mysterious approach to the sea is to be found in the works of another Norwegian painter, Knud Baade (1808–1879).[13] Studying with Dahl in Dresden, he settled eventually in Munich. Some of Baade's work show dramatic scenes of shipwrecks about to be swallowed by a stormy sea, while others are more melancholic; nightly scenes in the transcendental tradition of Friedrich → FIGS. 19, 20. As a late representative of the Romantic movement, Baade's paintings in some ways represent a staged version of the drama of nature.

THE FAR NORTH AND THE ARCTIC SEA

In 1832, yet another Norwegian painter, Peder Balke (1804–1887) made a voyage to the Northernmost parts of Norway, above the Arctic circle.[14] The mysterious—and mostly inaccessible—far North had, of course, fascinated people for centuries. This fascination seems to have been strengthened by Romantic artists and intellectuals' cult of the Sublime.[15] In for instance Mary Shelley's Gothic masterpiece, *Frankenstein* (1818), the opening scene takes place in the Arctic Sea. It is here, among the icebergs, that Dr. Frankenstein's monstrous creature so appropriately appears for the first time; echoing the images of the Northernmost parts of the

ocean from earlier centuries. In Edgar Allan Poe's short story, "A Descent into the Maelström" (1841), it is the overwhelming forces of nature in the Maelstrom or Mosktraumen by the Lofoten archipelago that takes center stage.

> *Here the vast bed of the waters, seamed and scarred into a thousand conflicting channels, burst suddenly into phrensied convulsion – heaving, boiling, hissing – gyrating in gigantic and innumerable vortices [...] Speeding dizzily round and round with a swaying and sweltering motion, and sending forth to the winds an appalling voice, half shriek, half roar, such as not even the mighty cataract of Niagara ever lifts up in its agony to Heaven.*[16]

Interestingly in our context, Poe's idea about the Maelstrom was based on the study old maps.[17] Later, in the 20th century, this natural phenomenon would be depicted by Modernists artists such as Per Krohg, who apparently was inspired by Poe's short story.

Friedrich, too, was fascinated by the idea of the icy wastes of the Arctic. *The Sea of Ice* (1823–24) → FIG. J shows a barren Arctic seascape where a ship is crushed between icebergs, where mankind must yield to the forces of nature. It is likely that Balke knew this painting from his later sojourns in Dresden, as it belonged to the collection of his mentor and teacher, Dahl. Neither Poe, Shelley nor Friedrich had ever traveled to the Arctic. For them, as for most artists and intellectuals of the time, the "North" was an idea that appealed to their aesthetic sensibility and imagination rather than a reality. However, a few artists had already found their way into the region. In 1799, for instance, the Swedish officer and artist, Anders Fredrik Skjöldebrand (1757–1834), had made a journey all the way to the North Cape, resulting in a volume of lithographs, *Voyage pittoresque au Cap Nord* (1801–02) → FIGS. 103–106.

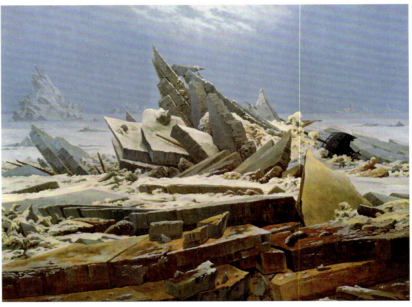

FIG. J Caspar David Friedrich, *The Sea of Ice*, 1823–24. Oil on canvas. Hamburger Kunsthalle.

Balke's journey is known through the artist's memoirs as well as his own pictures. Along the coast of Northern Norway, the artist traveled by ship—sometimes surprised by hurricanes—all the way to the North Cape and from there Eastbound to Vardø and Vadsø. A highlight of the trip was the North Cape; a plateau overlooking the vast, Ice Sea, then considered to be the northernmost part of the European Continent. In Vardø, a fortified port at the easternmost point of Finnmark, close to the Russian border, Balke went ashore to observe the effects of the sea:

> *[...] I felt I had to hold on tight to the cliff when the backwash hurled itself against the rock face and with a deafening sound like thunder rolled out again into the heaving sea, only to repeat the same fruitless onslaught on the unshakeable wall around which swirled the mighty waves of the Arctic Ocean.*[18]

The North Cape, Vardø and other motifs from the High North would become recurring subjects in Balke's production in the following decades → FIGS. 21, 22. His paintings should not, however, merely be regarded as coastal landscapes. For

instance, Balke often included steamboats, recognizing like Turner the advent of the modern, industrialized world at sea. A sympathizer with the early Labor movement of Norway, Balke was a social reformer who—among other causes—was concerned about the safety of sailors and campaigned for the building of lighthouses. Though an established motif, it is hard not to read Balke's depictions of lighthouses as a political statement.

Other artists would follow in Balke's wake, including the mentioned Baade. The different Polar expeditions of the 19th century contributed greatly to the imagery of the Arctic region. Such expeditions often had a stated scientific mission, while could at the same time have a political agenda; claiming new territories or at least creating national pride. In 1838–40, a French expedition—often referred to as the *Recherche* expedition—made a series of visits to the northernmost parts of Fennoscandia, Svalbard and Iceland. Alongside the scientists, different artists participated in the expedition to record the people, landscape and different natural phenomena they encountered. Art and science interacted from an early stage in the documentation of the Arctic. Their findings were recorded in a multi-volume publication, *Voyages de la Commission scientifique du Nord* (1842–56), including two volumes of prints, *Atlas historique et pittoresque*. Foremost among these artists was François-Auguste Biard (1798–1882), who joined the expedition in 1839, traveling to the northernmost parts of Norway, Sweden and Finland, as well as to Svalbard.[19] During the journey, Biard made studies of the Arctic nature, such as *From Magdalena Bay, Svalbard* (1839) → FIG. 28, as well as of people who he met. His studies are realist, documentary works, while the paintings that the artist composed in his Paris studio are of a more staged character. *Fighting Polar Bears* (1839) → FIG. 29 may have been painted before Biard visited the Arctic and seemingly reflects the somewhat Romantic idea that continental Europe had about the region, rather than being based on actual observations.

Born in the island community of Nesna, Hans Johan Frederik Berg (1813–1874) was one of the first artists who originated from Northern Norway.[20] In the 1860s–70s Berg executed a series of watercolors, portraying different Sámi people → FIGS. 25, 26. These differ from continental artists' more ethnographic depictions of Indigenous people as they so obviously are portraits of individual human beings. This is documented by the fact that the works have the names of the sitters inscribed, and they very likely represent people that the artist knew from the coastal community.

VISIONARIES

Balke would return to different motifs from the Arctic for the rest of his life. These works are not to be understood as topographical renderings, but rather as his inner visions of a particular landscape, based on memory. Much of Balke's artistic production can been seen as part of a process to find the form to visualize these visions. He would constantly experiment with his technique, limit the palette—sometimes into monochromes—and concentrate the composition almost to abstraction. This is especially true for his later paintings, from the 1860s–70s → FIG. 22.

A related approach is to be found in the works of the British painter Joseph Mallord William Turner (1775–1851), who painted several seascapes from the South Coast of England.[21] In some of his works from especially the 1830s–40s the form seems to dissolve into color and light in his renderings of atmospheric conditions → FIGS. 107, 108. Similar characteristics are also to be found in the works of Turner's contemporary, John Constable (1776–1837). Though based on care-

ful observations on clouds, waves and other natural phenomena, Constable too applies a dissolvement of form and colors as means to depict nature, especially in his studies →FIGS. 35, 36.[22]

An established artist, Turner became controversial during his later years because of his experimental way of painting, but the artist was also defended by among others John Ruskin. The critic praised Turner for his "truth to nature," but at the same time recognized the visionary dimension of his painting: "He saw also that the finish and specific grandeur of nature had been given, but her fulness, space and mystery never [...]."[23] Balke, who lived in London in 1849–50, must very likely have encountered the works of Turner.[24] Though superficially quite different, from different schools and countries, Turner and Balke may nevertheless be said to share certain ideals—or perhaps more correctly a background in the visionary current of Romanticism as well as an *attitude* in how to convey their motifs. Both artists adapted different, experimental techniques to convey their subjects.[25] While similar traits are to be found in other artists of the period—such as Friedrich or Constable—Turner and Balke went further than most in abstracting their visions of the ocean.

INTO THE MODERN WORLD

With the Realist and Naturalist currents of the second half of the 19th century, also the attitude to the sea changed. Rather than the grand and mysterious sea, the focus switched to the everyday life of sailors and of the fishing communities, as seen in the works of the different Scandinavian artists associated with the Skagen colony. For instance, Christian Krohg (1852–1925)—a leading painter in the Naturalist camp as well as an active social reformer and a writer—provides us in *Waitress at Work* (1901) →FIG. 58 with a glimpse into the life and work of women at sea, while Anna Ancher (1859–1935) has portrayed *An Old Fisherman's Wife* →FIG. 4. At the time, women artists started to make themselves noticed, both in the Nordic region and elsewhere. However, landscape painting—and especially maritime painting—was associated with the dangers of traveling and as such not deemed suitable for women. Still, some women defied both conventions and rough weather. One such pioneer was Betzy Akersloot-Berg (1850–1922), who traveled extensively in Northern Norway and even participated in a whaling expedition. Sketches made outdoors—often under harsh conditions—resulted in several coastal landscapes →FIG. 3.

Around the turn-of-the-century, the sea also became a place of recreation, as people would go to the seaside to swim or to sunbathe. This new, vitalist lifestyle is reflected in the works of different artists such as Joaquin Sorolla in Spain, Eugène Jansson (1862–1915) in Sweden and Edvard Munch (1863–1944) in Norway →FIGS. 48, 79, and is sometimes seen as a revolt against the perceived "decadent" manners of the 19th century's industrialized society. Jansson's paintings of sailors—like those of his fellow Swede, the Cubist Gösta Adrian-Nilsson (1884–1965; aka GAN)—reflect a new confidence in depicting love and sexuality between men, as showcased by Patrik Steorn in his essay in the present publication →FIGS. 1, 2.[26]

In the 20th century, artists would provide their Modernist interpretations of the sea, while at the same time often referring to the works of their predecessors.[27] In for instance the paintings of Anna Boberg (1864–1935), the spectacular Lofoten nature echoes the Romantics fascination for the Sublime in her depictions of natural phenomena such as the northern lights →FIGS. 30, 31. Boberg, a Swedish

painter and designer, visited the archipelago regularly in the early 1900s; a topic explored further by Martin Olin in his essay in this catalogue.

In the 1920s and '30s, many painters—such as the Norwegians Per Krohg and Axel Revold as well as the Swedes Sven 'X-et' Erixson and Albin Amlin—were politically and socially committed, and preoccupied with the conditions of working people, as reflected in their depictions of sailors and fishermen.[28] In *The Fishing Fleet Leaves the Harbour* (1935) → FIG. 91, Axel Revold (1887–1962) presents us with the modern industrialization of the fishery. Arne Ekeland (1908–1994)—as seen in his painting *Lofoten Fishermen* (1935) → FIG. 42—is preoccupied with people at work. A related subject-matter is found in the monumental, mixed-media work *Fishherman* in *Lofoten with his Catch* (ca. 1970) → FIG. 82 by Rolf Nesch (1893–1975); an artist who had fled Nazi-Germany in favour of Norway before World War II. Per Krohg (1889–1965), on the other hand, seemingly looks back to the old mapmakers as well as to Romantic painters and writers—like Balke or Poe—in his dramatized depiction of *The Maelstrom* (1929) → FIG. 59.[29]

The Swedish-Norwegian artist Anna-Eva Bergman (1909–1987), too, was inspired by the coastal landscape, traveling to the northernmost parts of Norway twice. Bergman's interest seems to have been mostly formal or aesthetic, and she would eventually abstract this solemn nature into iconic shapes, sometimes using gold, silver or other metals to achieve striking visual effects → FIG. 27.

The Atlantic Ocean—as well as Atlantis as its mythological offspring—has continued to fascinate artists, scientists and other thinkers up to the present day. (For a more in-depth investigation of the image of the Atlantic today, see Stefanie Hessler's essay in this publication.) To some extent, many modern and contemporary artists seem to relate to the depictions of their predecessors. The legend of Atlantis or other myths associated with the ocean still holds its sway. But even the Romantic image of the Atlantic is still alive, as seen in the works of for instance David Hockney or in Matías Duville's large-scale drawings of roaring waves → FIGS. 40, 41. Then again, others are more interested in the harsh realities of the labors related to the sea industries—such as Allan Sekula in his extensive documentary project *Fish Story* (1988–93) → FIGS. 94–100—while also pointing out the advantages as well as problems connected with the idea about the ocean as a communal larder or source of infinite resources—as Armin Linke does in *Prospecting Ocean* (2018; → FIGS. 62–68).

Endnotes

1. Plato (428/427–348/347 BC) mentions Atlantis in his dialogues *Timaeus* and *Critias*.
2. [...] jag komme till de stränder där Asparlundarna äro fulla med gyllene äpplen, där näcken regerar havet och låter ingen vidare till sjöss segla där jordens och himmelens ända är vars vändepunkt Atle håller - där som Malströmmen är all havsens källa , där Thor haver sitt säte [...]. Olof Rudbeck, *Orfeus drager norråt*, edited and with an introduction by Gunnar Eriksson. Stockholm: Atlantis, 2001, pp. 29–30. English translation by Gabriella Berggren.
3. Benedicte Gamborg Briså, "Mapping the expansion of the known world in the north," in *Norsk Geografisk Tidsskrift / Norwegian Journal of Geography*, vol. 74, no. 4, 2020.
4. William B. Ginsberg, *Printed Maps of Scandinavia and the Arctic: 1482–1601*. New York: Septentrionalium Press, 2006.
5. Erling Sandmo, *Monstrous: Sea Monsters in Maps and Literature 1491–1895*. Oslo: National Library, 2017.
6. Herman Melville, *Moby-Dick or, the Whale* (1851). London: Penguin, 2003, pp. 7–8.
7. Bodil Sørensen, "'Fra den yderste Spids af Lofoten': Theodor Kittelsens nordnorske eventyr," in Anne Aaserud (ed.), *Nordnorske bilder og bildet av Nord-Norge*. Tromsø: Northern Norway Art Museum, 2022.
8. Hanne Beate Ueland (ed.), *Frida Hansen: Art nouveau i full blomst / Art Nouveau in Full Bloom*, exhibition catalogue. Stavanger: Stavanger Art Museum, 2023.
9. Edmund Burke, *A Philosophical Enquiry into the Origin of our Ideas of the Sublime and Beautiful* (1757). Oxford: Oxford University Press, 1990, p. 37.
10. Sabine Mertens, *Seesturm und Schiffbruch: Eine motivgeschichtliche Studie*. Hamburg: Ernst Kabel Verlag, 1987, pp. 83–88.
11. Carl Gustav Carus, *Nine Letters on Landscape Painting* (1831), translated from German by David Britt, with an introduction by Oskar Bätschmann. Los Angeles: Getty Research Institute, 2002, p. 96.
12. Marie Lødrup Bang, *Johan Christian Dahl 1788–1857: Life and Works*, vols. 1–3. Oslo: Universitetsforlaget, 1987.
13. Knut Ljøgodt, *Måneskinnsmaleren / Moonlight Romantic: Knud Baade (1808–1879)*. Stamsund: Orkana, 2012.
14. See Knut Ljøgodt, *Peder Balke: Sublime North: Works from The Gundersen Collection*. Milan: Skira, 2020 for further references. See also Marit Ingeborg Lange, Knut Ljøgodt, and Christopher Riopelle, *Paintings by Peder Balke*, exhibition catalogue. London: National Gallery and Yale University Press, 2014.
15. Anne Aaserud (ed.), *Voyage pittoresque: Reiseskildringer fra nord*, exhibition catalogue. Tromsø: Northern Norway Art Museum, 2005; Knut Ljøgodt, *Peder Balke: The Spell of the Arctic*, exhibition catalogue. Helsinki: Finnish National Gallery – Sinebrychoff Art Museum, 2023.
16. Edgar Allan Poe, "A Descent into the Maelström," in *The Complete Tales and Poems*. London: Penguin, 1982, pp. 128–129.
17. Edgar Allan Poe, *Mannen fra mengden og andre noveller*, translated to Norwegian and with a commentary by Stig Sæterbakken. Oslo: Bokvennen, 2000, pp. 95–97 and 107–111.
18. Balke's memoirs, quoted from Marit Ingeborg Lange, "Peder Balke," in Lange, Ljøgodt and Riopelle 2014, p. 20.
19. Anne Aaserud, "Le peintre de cour et le prédicateur: Trois peintures de François Auguste Biard dans le collections du Musée des Beaux-Arts de la Norvége du Nord," in Per Kværne and Magne Malmanger (eds.), *Un peintre norvégien au Louvre: Peder Balke (1804–1887) et son temps*. Oslo: Novus Press and The Institute for Comparative Research in Human Culture, 2006; Adèle Akamatsu and France Nerlich, "'Painting almost under the North Pole': François-Auguste Biard and the invention of the landscape of the Great North," in Éric de Chassey (ed.), *Savage Bareness: Painting the Great North*. Paris: Institut national d'histoire de l'art, 2019.
20. Ann Falahat, *Fra Nesna til Nilen: Akvareller fra Hans Johan Frederik Bergs reiser*, exhibition catalogue. Tromsø: Northern Norway Art Museum, 2007.
21. David Blayney Brown, Amy Concannon and Sam Smiles (eds.), *Late Turner: Painting Set Free*, exhibition catalogue. London: Tate Britain, 2014.
22. Mark Evans, *John Constable: The Making of a Master*, exhibition catalogue. London: Victoria and Albert Museum, 2014.
23. John Ruskin, *Modern Painters*, vol. 1 (1842). London: 1923, p. 125.
24. Ljøgodt 2020, pp. 64–66, 69.
25. Knut Ljøgodt, "Visionary Romantics: From Inner Landscape to Experimental Form," in Knut Ljøgodt and Carlos Sánchez Díez (eds.), *Visionary Romantics: Balke – Lucas – Hertervig*, exhibition catalogue. Madrid and Stavanger: Centro de Estudios Europa Hispánica, Museo Lázaro Galdiano, Stavanger Art Museum and Nordic Institute of Art, 2023.
26. Göran Söderström (ed.), *Sympatiens hemlighetsfulla makt: Stockholms homosexuella 1860–1960*, Stockholm: Stockholmia Förlag, 1999; Patrik Steorn, *Nakna män: Maskulinitet och kreativitet i svensk bildkultur 1900–1915*. Stockholm: Norstedts Akademiska Förlag, 2006.
27. Anne Aaserud and Knut Ljøgodt (eds.), *Fra Paris til Svolvær: Kunstnere i Lofoten i mellomkrigstiden*, exhibition catalogue. Tromsø: Northern Norway Art Museum, 2006.
28. Aaserud and Ljøgodt 2006; Kathrine Lund, *Kunst og kamp: Sosialistisk kulturfront*. Oslo: Orfeus, 2012.
29. Trygve Nergaard, "Per Krohg i Lofoten," in Aaserud and Ljøgodt 2006, p. 60.

GÖSTA ADRIAN-NILSSON (GAN)
BETZY AKERSLOOT-BERG
ANNA ANCHER
PIA ARKE
KADER ATTIA
KNUD BAADE
PEDER BALKE
WILLEM BARENTSZ
ADOLPHE JEAN BAPTISTE BAYOT
HANS JOHAN FREDERIK BERG
ANNA-EVA BERGMAN
FRANÇOIS-AUGUSTE BIARD
ANNA BOBERG
DINEO SESHEE BOPAPE
FRANZ LUDWIG CATEL
JOHN CONSTABLE
JOHAN CHRISTIAN DAHL
MARJOLIJN DIJKMAN &
TORIL JOHANNESSEN
MATÍAS DUVILLE

WORKS

A–D

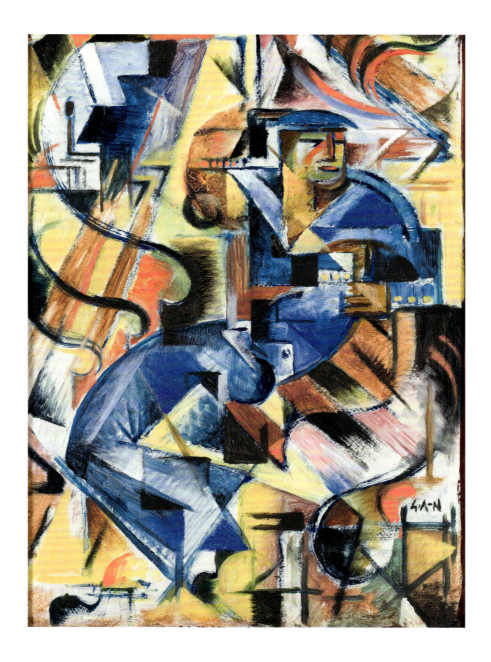

FIG. 1 *Sailor*, 1918
Oil on cardboard
Moderna Museet, Stockholm
Purchase, 1931
Photo: Moderna Museet/Tobias Fischer
© Gösta Adrian-Nilsson/BONO 2024

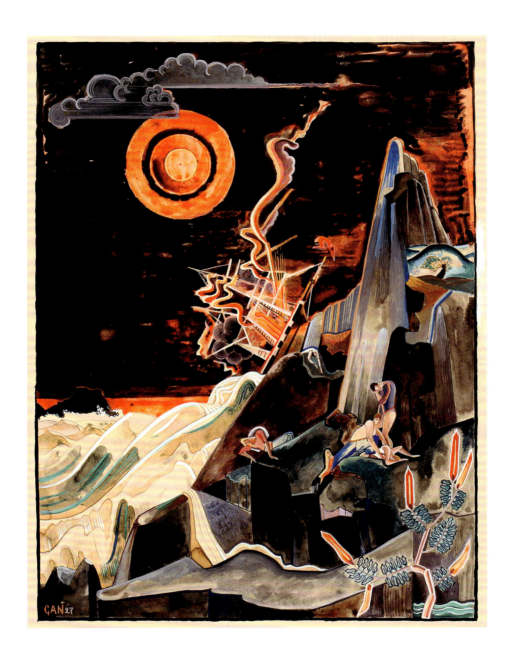

FIG. 2 *The Shipwreck*, 1927
Gouache on paper
Malmö Konstmuseum
Photo: Malmö Konstmuseum/Vladimira Tabáková
© Gösta Adrian-Nilsson/Malmö Konstmuseum/BONO 2024

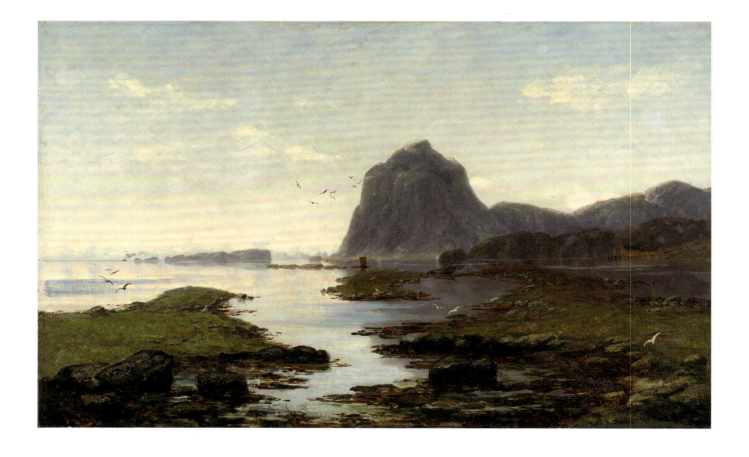

FIG. 3 *From Lofoten*, 1880s
Oil on canvas
Nasjonalmuseet for kunst, arkitektur og design, Oslo
Photo: Nasjonalmuseet/Børre Høstland

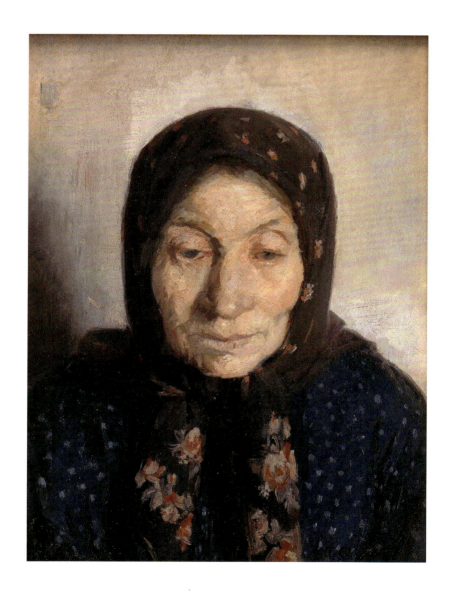

FIG. 4 *An Old Fisherman's Wife*, 1874–1912
Oil on canvas
Statens Museum for Kunst, Copenhagen
Photo: openSMK/public domain

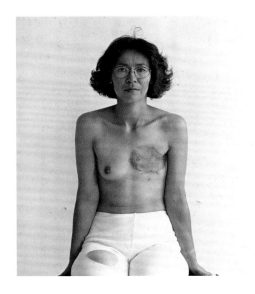
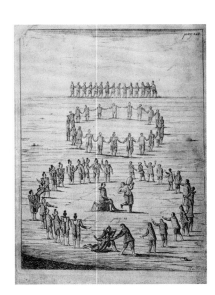

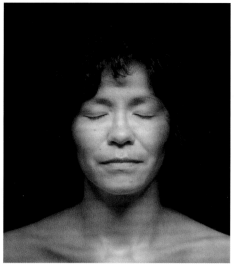

FIGS. 5–14 *Nature Morte alias Perlustrations I–X*, 1994
　　　　　　Gelatine silver prints
　　　　　　Moderna Museet, Stockholm
　　　　　　Donation 1995 from the artist
　　　　　　© Pia Arke/BONO 2024

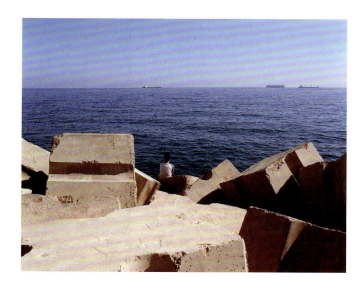

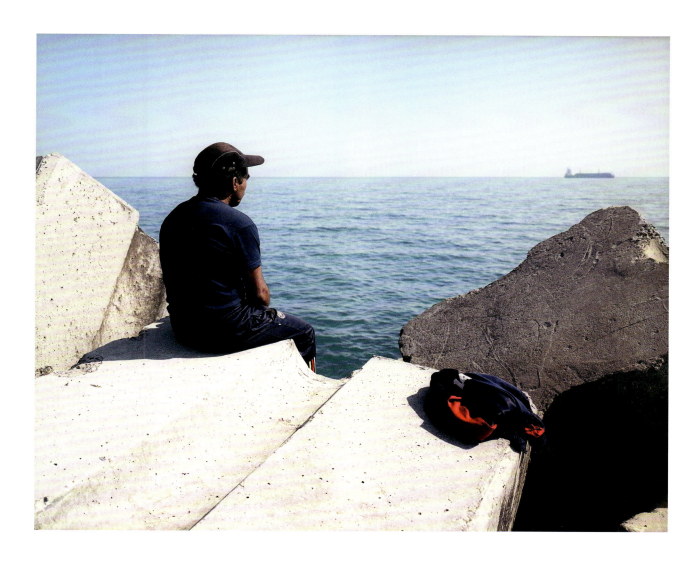

FIGS. 15–18 *Rochers Carrés*, 2008
Gelatin silver prints
Courtesy the artist and Galerie Nagel Draxler

FIG. 19 *Shipwreck*, 1839
Oil on canvas
Nasjonalmuseet for kunst, arkitektur og design, Oslo
Photo: Nasjonalmuseet/Børre Høstland

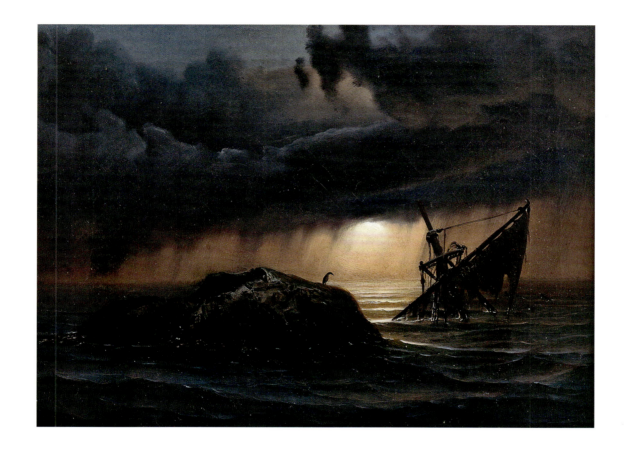

FIG. 20 *Shipwreck with Gannet*, 1845
Oil on canvas
SpareBank 1 Nord-Norges kunststiftelse, Tromsø
Photo: SpareBank 1 Nord-Norges kunststiftelse

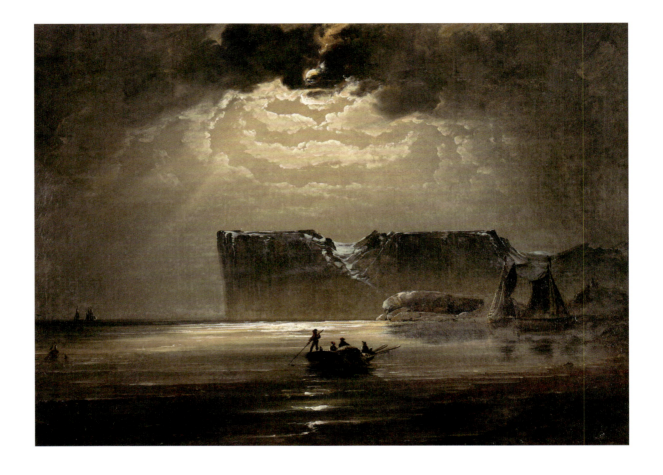

FIG. 21 *North Cape*, 1848
Oil on canvas
The Gundersen Collection, Oslo
Photo: Morten Henden Aamot

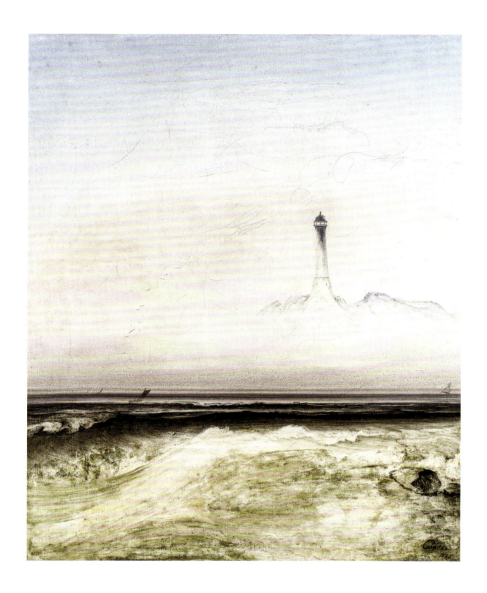

FIG. 22 *Lighthouse in Mist*, 1865
Oil on canvas mounted on panel
The Gundersen Collection, Oslo
Photo: Morten Henden Aamot

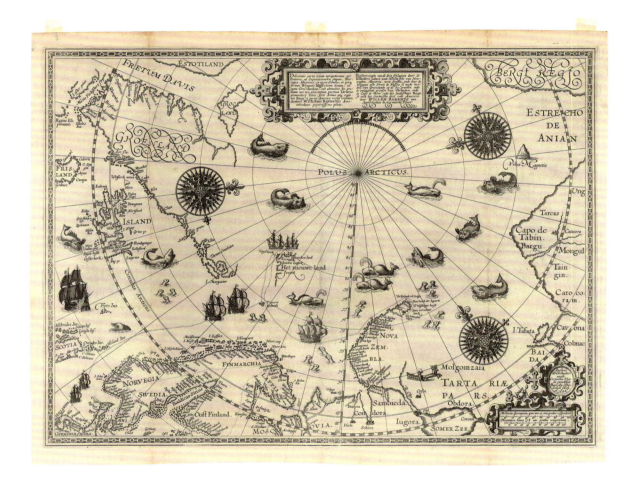

FIG. 23 *Deliniatio Cartae Trium Navigationum per Batavos, ad Septentrionalem plagam, Norvegiae, Moscoviae, et novae Semblae*, first map of the Arctic to include Spitzbergen, 1598
Copperplate engraving on paper
Nasjonalbiblioteket, Oslo
Photo: Nasjonalbiblioteket

ADOLPHE JEAN BAPTISTE BAYOT, AFTER AUGUSTE MAYER

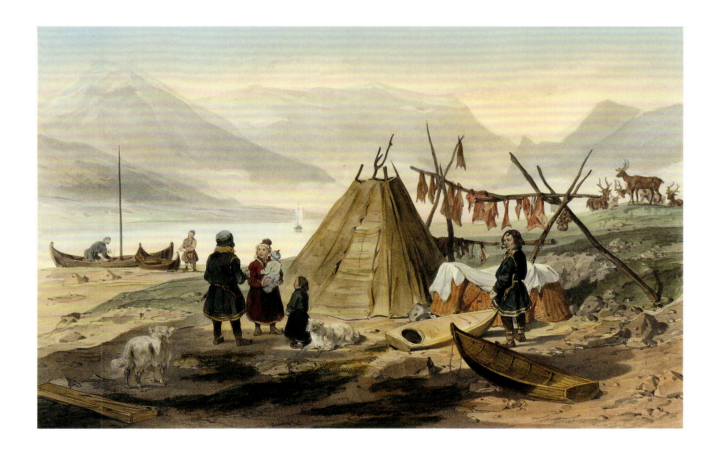

FIG. 24 *Sámi Tent, Magerøya, Finnmark*, 1842–56
Hand-colored litograph on paper
Nordnorsk Kunstmuseum, Tromsø
Photo: Nordnorsk Kunstmuseum

FIG. 25 *Lars Olsen, Hamnvik*, 1870
Watercolor on paper
Nasjonalmuseet for kunst, arkitektur og design, Oslo
Photo: Nasjonalmuseet/Andreas Harvik

HANS JOHAN FREDERIK BERG

FIG. 26 *Group of Sámis by a Boat*, 1871
Watercolor, gouache and pencil on paper
Nasjonalmuseet for kunst, arkitektur og design, Oslo
Photo: Nasjonalmuseet/Andreas Harvik

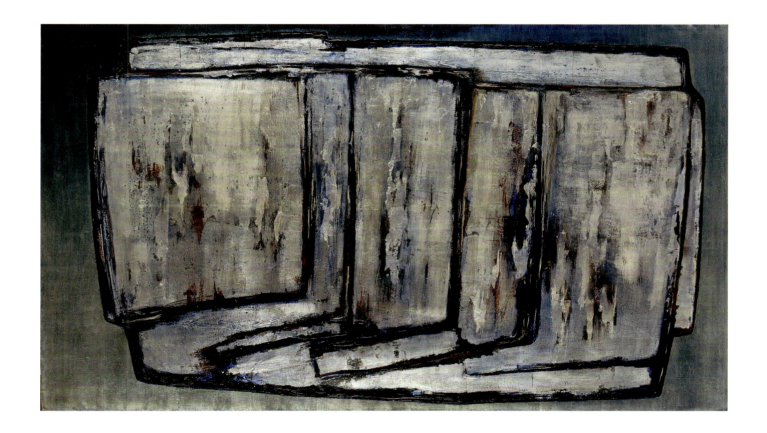

FIG. 27 *Iceberg*, 1957
Oil and silver on canvas
Henie Onstad Kunstsenter, Høvikodden
Photo: Henie Onstad Kunstsenter/Øystein Thorvaldsen
© Anna-Eva Bergman/BONO 2024

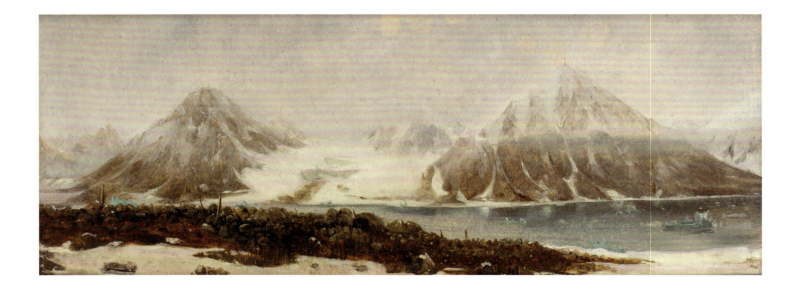

FIG. 28 *From Magdalena Bay, Svalbard*, 1839
Oil on canvas
Nordnorsk Kunstmuseum, Tromsø
Photo: Nordnorsk Kunstmuseum/Kim G. Skytte

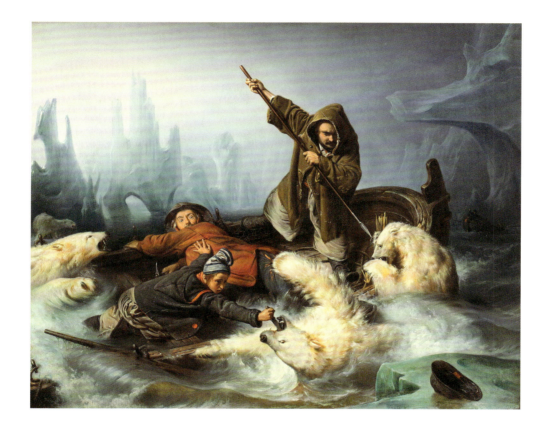

FIG. 29 *Fighting Polar Bears*, 1839
Oil on canvas
Nordnorsk Kunstmuseum, Tromsø
Photo: Nordnorsk Kunstmuseum/Kim G. Skytte

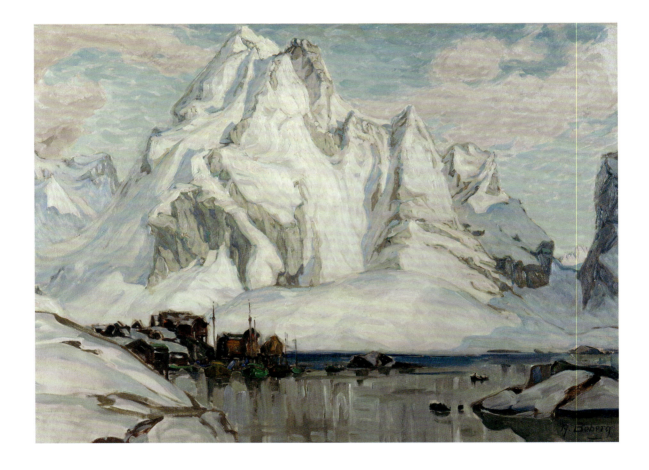

FIG. 30 *After the Massacre. Study from Northern Norway*, early 1900s
Oil on canvas
Nationalmuseum, Stockholm
Photo: Nationalmuseum/Cecilia Heisser

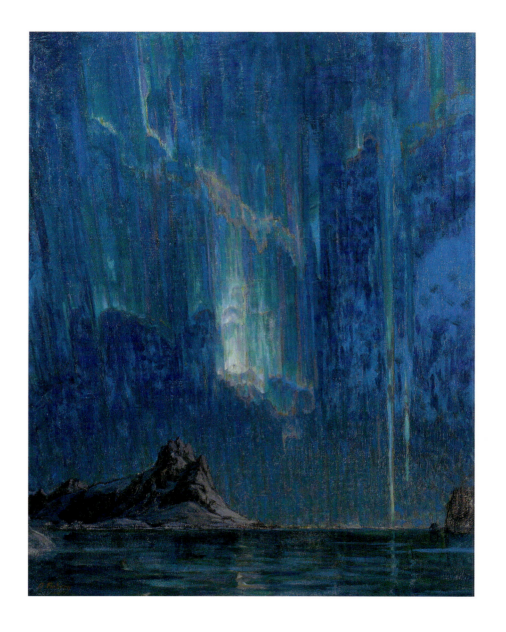

FIG. 31 *Northern Ligths: Study from Northern Norway*, early 1900s
Oil on canvas
Nationalmuseum, Stockholm
Photo: Nationalmuseum/Anna Danielsson

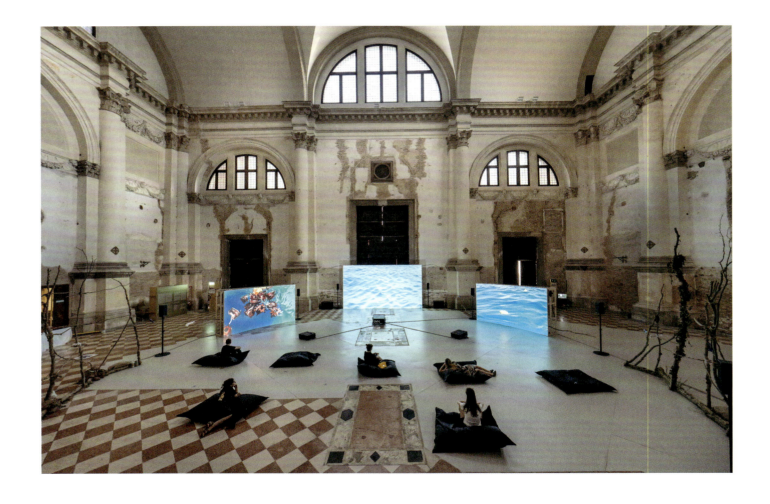

FIG. 32 Installation views from *The Soul Expanding Ocean #3: Dineo Seshee Bopape*, Ocean Space, Venice, 2022
Courtesy the artist
Photo: Matteo De Fina

FIG. 33 Still from *Lerato laka le a phela le a phela le a phela/ My love is alive, is alive, is alive*, 2022
Multi-channel video and sound installation
Courtesy the artist

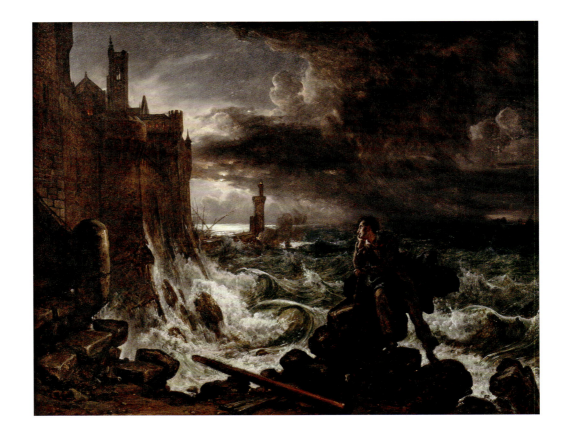

FIG. 34 *Night piece, from the closing scene of "René" by Chateaubriand*, early 1800s
Oil on canvas
Thorvaldsens Museum, Copenhagen
Photo: Thorvaldsens Museum/Jakob Faurvig

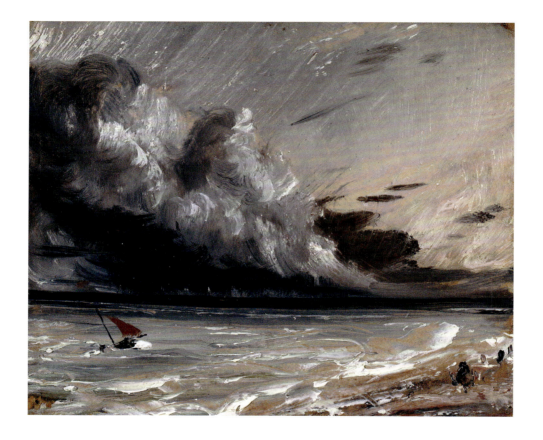

FIG. 35 *Seascape Study: Boat and Stormy Sky*, 1828
Oil on paper laid on board
Royal Academy of Arts, London
© Royal Academy of Arts, London
Photo: John Hammond

JOHN CONSTABLE

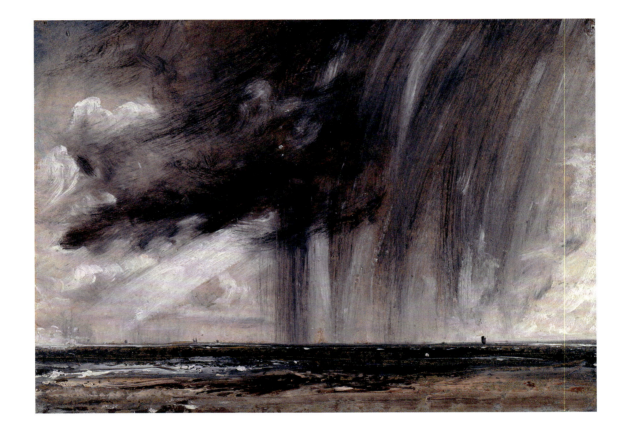

FIG. 36 *Rainstorm over the Sea*, ca. 1824–28
Oil on paper laid on canvas
Royal Academy of Arts, London
© Royal Academy of Arts, London
Photo: John Hammond

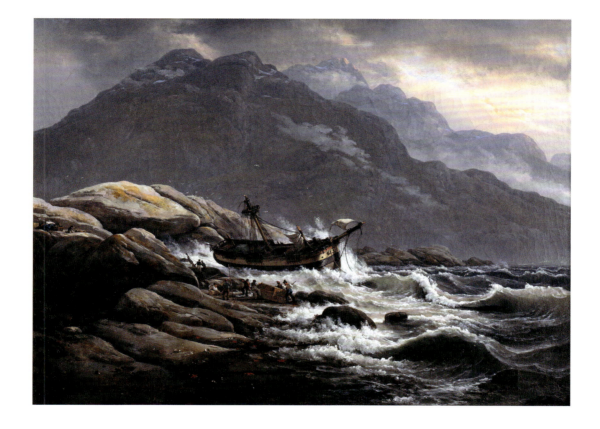

FIG. 37 *Shipwreck by the Coast of Norway*, 1830
Oil on canvas
DNV AS
Photo: Øystein Thorvaldsen

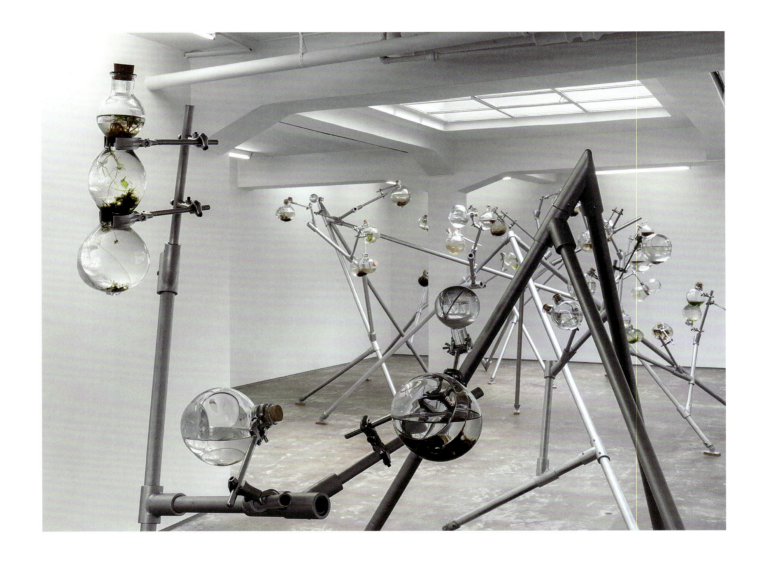

FIG. 38 *Liquid Properties*, 2018
Hand-blown glass objects, water samples, microorganisms, metal structure
Commissioned by The Munch Museum for Munchmuseet on the Move, 2018
Courtesy the artists and OSL Contemporary

FIG. 39 Still from *Reclaiming Vision*, 2018
Film (HD), stereo sound
Commissioned by The Munch Museum for Munchmuseet on the Move, 2018
Courtesy the artists

FIGS. 40–41 *Desert means Ocean*, 2019
Sanguina on paper, diptych
Photo: MOOLA (Museum of Latin American Art)
Courtesy the artist and Barro Gallery

THE ALLURE OF SEAMEN. SAILOR SUITS AND HOMOEROTIC DESIRE IN ART AROUND 1900

Patrik Steorn

Life at sea has inspired many artists over the years, but sailors did not make their appearance as a prominent artistic trope until the 19th century. Initially, they were mostly found in the pages of sketchbooks of artists trying to capture characters in street life. During that period, uniforms also became more widely used in European costume history, both in military and civilian professions.[1] Sailor suits are not among the more showy or over-decorated uniforms—on the contrary, they are fairly modest. The round cap, the square collar covering the upper back, the loose smock, the striped shirt, bell-bottomed wide-legged trousers and tapered waist give the wearer a distinct, not to say graphic, style. The decorations consist solely of braids and stripes that accentuate the body, in contrasting colors—white or blue—and the occasional detail in bright red.

The sailor suit has had a strong appeal in the visual culture of art, fashion and advertising ever since the previous turn of the century. Since the 19th century, this uniform has also served as an erotic signal in the gay subcultures that emerged in Europe. Soldiers and sailors were associated with strong masculinity, and their uniforms have shaped the image of the ideal male body with broad shoulders and narrow hips. Sailors have become a homoerotic icon that can be both playful and accessible, while inspiring respect and exuding virility.

In Nordic art, two artists in particular, Eugène Jansson and Gösta Adrian-Nilsson on either side of 1900 have portrayed the ambiguous attraction of sailors and their garb. This essay looks at their practices, to describe how homoerotic desire could be incorporated in the artistic process.

MEN, SAILORS, AND MODELS. EUGÈNE JANSSON

A strong, energetic, self-controlled and authoritarian type of masculinity, unlike the slender androgynous dandy of urban culture, appeared in Nordic art around 1900. Athletic men became a kind of vitalist figureheads, in the symbolic fight against the popular notion that Western culture was degenerating.[2] Workers, sailors and other physically active men were perceived as more masculine than

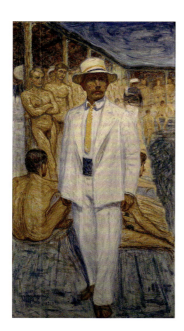

FIG. K Eugène Jansson, *Self-portrait*, 1911. Photo: Nationalmuseum, Stockholm, public domain.

the suit-wearing gentlemen from the upper and middle classes. Thus, they came to be associated with the vitalist civilizational critique and its striving to regenerate art. At the same time, these men were presented as physically attractive and available to women and men alike.

It was around 1900 that awareness of homosexuality, mainly among men, spread in Europe and the Nordic countries.[3] Sexual acts between people of the same sex naturally occurred even before then, but the word homosexuality was not launched until the late 1800s. In the decades leading up to 1900, homosexual acts were criminalized in all Nordic countries. Homosexual acts were prohibited in Norway in 1842, in Sweden in 1864, in Denmark in 1866, in Iceland in 1869, and in Finland in 1889.[4] While scientific, legal, media and literary texts introduced homosexuality as a concept, there were possibilities around the turn of the century to build a homosexual identity, with cultural communities and places to meet socially. But homosexuality was also regarded as an unpredictable behavior that could arise spontaneously and temporarily, regardless of explicit identity.

The artist Eugène Jansson (1862–1915) is best known in Swedish art history for his paintings from the 1890s of blue-tinted twilight views of Stockholm. In the early 1900s, his themes shifted from deserted city streets and quays to naked, muscular men moving around in bright sunlight. The navy outdoor baths in the military zone on Skeppsholmen in Stockholm attracted the artist both as a sports arena, a source of inspiration and a social and erotic meeting place. In a monumental self-portrait from 1910, Eugène Jansson presents himself as a self-aware artist in a white linen suit, against a backdrop of sailors and nude, sunbathing men → FIG. K.

Preserved photographs, on the other hand, show him as a toned, suntanned athlete. Some thirty photographs from the Navy baths are found in the artist Nils Santesson's archive in the National Library of Sweden. Santesson was one of the men who were sentenced for homosexual activities in the early 1900s. The pictures indicate that Jansson and Santesson moved in the same circles in Stockholm. Jansson appears in some twenty of these photos and may have taken the others. Texts describing the artist's life also stress that he eagerly and enthusiastically spent hours at the baths.[5] His self-portrait shows him as an artist on a visit, and a mere onlooker. In the photographs, however, he looks like a regular, a man enjoying swimming and sunbathing without clothes among the sailors and other men → FIG. L. This environment enabled him to alternate between the roles of participant and spectator.

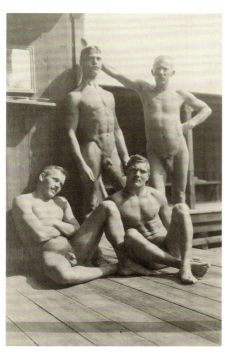

FIG. L Eugène Jansson with Knut Nyman and unknown men at Flottans badhus at Skeppsholmen in Stockholm, 1910s. Kungliga biblioteket, HS L 30:11:2:11, Stockholm. Reproduction: Anna Guldager, Kungliga biblioteket.

There are many descriptions of Eugène Jansson's close relations with his male models. Different men who served as models are mentioned as companions in restaurants, on holiday and at dinners, and as his carers towards the end of his life.[6] The close affinity between artist and model is also manifested in how Jansson has written the name of the models next to the graphite and oil sketches of their naked bodies. Knut Nyman, Julle Dahlgren, Otto Skånberg, Frans Welin, known as Tippo, and Carl Gyllin are some of the men who were painted or drawn nude as they posed, exercised or relaxed in Jansson's studio.[7] Several were sailors Jansson had met at the baths on Skeppsholmen. The artist seems to have blurred the line between private and professional life, leaving scope for an intimacy between the artist and his models that stimulated his artistic practice while being of an erotic nature.

THE ALLURE OF SEAMEN

Bath House Scene (1908) → FIG. 48 was painted at the Navy baths, where a large group of young men are gathered around the pool; in the background, some are wearing sailor suits. The men stand, sit, half-recline in various poses, and all are looking intently at a diver captured mid-leap above the water's surface. But the focus is on the male spectators, and our observation of those who are looking is turned into a double voyeurism. The monumental paintings *Sailor's Ball I* (1909) → FIG. M and *Sailor's Ball II* (1912) are also painted from the viewer's position. On Sundays, dances were held in the Drill Hall on Skeppsholmen, a popular event that Jansson made into a scene for his art. Signal flags in lurid colors hang from the ceiling together with brightly-shining chandeliers, intensifying the mood of the entire room. The sailors in their white uniforms dominate the dancing crowd, with occasional accents of colors here and there from the ladies' dresses.

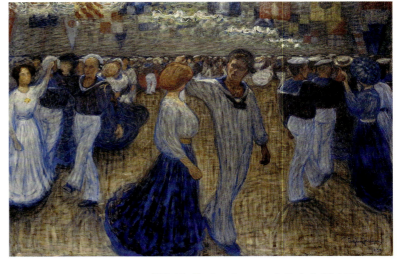

FIG. M Eugène Jansson, *Sailor's Ball I*, 1909. Thielska Galleriet, Stockholm. Photo: Thielska Galleriet/Tord Lund.

The sailor suit is easy to spot in the urban setting, a distinct visual signal that attracts the eye. It was general knowledge that sailors and soldiers made a bit of extra money by having sex with men, to the extent that their uniforms could serve as a signal of sexual availability.[8] *Spring Sun* (presumably 1880s) → FIG. N is a pastel by Jansson of two sailors, one in a white uniform, the other in dark blue, sitting on a bench in a lush park in Stockholm. One of the men gazes with a wide, expectant smile straight at the other man, who sits with his back to the viewer—a separated sphere is created around their encounter. The smile and their contact portray a meeting between men who could just as well be friends or colleagues or lovers. The unpredictable potential imbues the painting with inherent energy. Even if Jansson was drawn to sailors both with and without clothes, their uniforms perhaps had a special allure. In a photograph taken in 1907 at a costume ball at the residence of the Thiel family, the artist's most important patron at the time, the artist is wearing a sailor's outfit: dressed as his own favourite motif.

The homoerotic content in Eugène Jansson's paintings was probably blatant, especially to those who were familiar with the codes of gay subculture.[9] His paintings offered women and men from the majority culture a closer look at intimately-portrayed male bodies—both nude and in sailor costume.

FIG. N Eugène Jansson, *Spring Sun*, presumably 1880s. Pastel on paper. Private collection. Photo: Per Myrehed.

ABSTRACTION AND SAILOR ROMANTICISM.
GAN AND OTHER MODERNISTS

In the 1910s, Gösta Adrian-Nilsson, GAN (1884–1965) → FIGS. 1, 2 developed his own modernist style to express the homoerotic gaze. This took place in dialogue with established visual traditions for portraying the male body's sensual potential in art. A geometricizing and fragmented method of composition made it possible for him to covertly, yet explicitly, paint a homoerotic gaze on male bodies. This style allowed him to combine modernism with a desiring gaze that does not immediately reveal the motif, but seduces the viewer and tempts to a more intense seeing. At first glance, a painting such as *White Sailor in Landscape* (1917) represents a sailor in a white uniform looking straight ahead. On closer inspection, the viewer will discover that the man is half-reclining with parted legs. His groin is in the center of the painting, with the outline of his genitals distinctly visible. At the lower edge of the painting, a sailor in a blue suit looks straight at the posing man.

Gösta Adrian-Nilsson wanted art to be veritably fizzing with its own inner and powerful animation. In 1915, responding to the art critic Adolf Anderberg, who was baffled by his work, GAN wrote: "Art is [...] life being lived, and the living spirit itself in its perpetually-shifting beauty."[10] GAN saw art as a masculine being, creating its aesthetic form without adapting to the surroundings, with a physical, almost corporeal presence: "The truly cultivated [...] is vivid and *strong, brightly-coloured*, not concept but blood and flesh."[11] The sailors represented values that GAN admired: strength, movement and beauty, not just aesthetically but also physically.

In the late 1910s, the artist moved to Stockholm, and his diaries contain accounts of how he would go about town to meet up and have casual sex with other men. The painting *Sailor* (1918) → FIG. 1 captures a fleeting glance from a sailor in blue sitting on a tram. It was well-known that the blue smock in particular held a special allure to GAN, like a fetish, an object that the individual has invested with a strong sexual charge: "And there lay your gift—the blue smock that is a pleasure to wear. It was pleasure-worn yesterday. In the royal navy's work uniform I loved you!! In that uniform I shall paint the divine blue in you."[12]

Nightlife provided the inspiration for a series of paintings called *The Sailor Suite*.[13] Sailors, guards and hussars appear in these paintings in urban settings that were well-known to be places for homosexual cruising; from the restaurants and bars around Kungsträdgården in Stockholm, especially Berns and Berzelii park, to the harbour district around Katarinahissen on Södermalm and the Gröna Lund fairground at Djurgården. In one painting in the series, *Sailors at Gröna Lund's Tivoli II* (1918) → FIG. O, GAN interweaves the modernist imagery with nightlife scenes and a lustful observation of male bodies. The sailors have taken over, filling the fairground in GAN's painting. Three sailors in the foreground have their backs turned, as they each cooly light their cigarettes, but the man to the far right perhaps gets to embody the artist's expectations on the night—rugged, muscular and handsome, captured in mid-movement. The artist's scrutiny of the crowd, and the encounters that could arise, are transformed into creative energy on these canvases that are brimming with desire and abandon, a visual intoxication that is imparted to the viewer through strong colors and bold designs. The painting gives us a glimpse of the urban street life that captivated GAN and offered him material for his artistic vision.

Turning now to the world at large, there were other early modernist artists who also featured the sailor uniform as a symbol of homoerotic desire and gay relationships. In the USA, Marsden Hartley (1877–1943) and Charles Demuth (1883–1935) were close friends and worked hard on finding ways to include their personal experiences as gay men in the emerging new American art.[14] A series of watercolors by Demuth portrays meetings with sailors—from visiting art galleries together, to sexual encounters in the port. Hartley has become best known for his portraits of military men with whom he had relationships. These men are reduced to medals, uniform details and sharply contoured planes. British artist Edward Burra (1905–1976) filled his large canvases with soldiers and sailors of different skin colors in dingy bars. Inviting glances, gestures and bodies mix with frosty masks and an underlying darkness.[15] Like the two Swedish artists, they developed strategies to use the modernist style to tell, more or less covertly, about homosexuality as a facet of

FIG. O Gösta Adrian Nilsson (GAN), *Sailors at Gröna Lund's Tivoli II*, 1918. Private collection. © Gösta Adrian-Nilsson/BONO 2024.

THE ALLURE OF SEAMEN

modern life. The sailor suit was a vital component of this aesthetic, which glorified a strong, yet vain and inviting, masculinity.

Homoerotically inclined artists were not the only ones to be enticed by the ambiguous masculinity of the sailor's suit, however. The French artist Henri Matisse (1863–1954) painted *A Young Sailor II* (1906) in a provocative pose, emphasizing the young man's decorative look. In Sweden, Sigrid Hjertén (1885–1948) painted *Ivàn in a Blue Sailor Shirt* (1923), where the costume seems to emphasize her son's unwillingness to pose. Swedish Ragnar Sandberg (1902–1972) painted a whole series of sailors in the 1930s, finding his motifs in the ports of towns like Marseille and Toulon, and the small seaside resort of Les Sablettes on the French Riviera, where he traveled with his then wife Elsa. The white service wear is dazzling in the bright sun, and the sailors often flock together → FIG. P. Their outfits make them into a unit, and male community is portrayed as a motif teeming with life and energy. Sandberg had also studied sailors in his home town of Gothenburg, and their dress seems to symbolise a folksy social scene alongside bourgeois life.

FIG. P Ragnar Sandberg, *Sailors in Toulon*, 1937. Private collection. © Ragnar Sandberg/BONO 2024.

The sailor in art is a visual tradition in its own right, attracting Western artists of all genders and sexualities. But they have nevertheless been especially alluring to men who love men. The blue-and-white uniform has been associated with intimate male community, a border state between sea and land, between work and private life, between life phases. Notions of independence from social conventions and a folksy, simpler and freer life at sea have given rise to creativity in art, fashion, photography and drawings by, for instance, the designer Jean Paul Gaultier, the illustrator Tom of Finland and the watercolorist Lars Lerin. Homoerotic desires have been there since the 1800s as an underlying urge, a fascination that has grown more established in the majority culture in recent decades. Eugène Jansson and GAN belonged to the early generations of artists who, with a desiring and aesthetic gaze, scrutinized the male body and contributed to a reconsidering of the stereotype of the strong, masculine sailor, by asserting their own pleasureful and playful way of seeing.

Endnotes

1. Elizabeth Hackspiel-Mikosch, "Uniforms and the Creation of Ideal Masculinity," in Peter McNeil, Vicki Karaminas (eds.), *The Men's Fashion Reader*. Oxford: Berg, 2009.
2. Patrik Steorn, *Nakna män. Maskulinitet och kreativitet i svensk bildkultur 1900–1915*. Stockholm: Norstedts akademiska, 2006.
3. Greger Eman, "1907: 'Det homosexuella genombrottet'," in Göran Söderström (ed.), *Sympatiens hemlighetsfulla makt. Stockholms homosexuella 1860–1960*. Stockholm: Stockholmia, 1999, pp. 149–155.
4. Decriminalization took place gradually in the Nordic countries; Denmark in 1930, Iceland in 1940, Sweden in 1944, Finland in 1971 and Norway in 1972. Jens Rydström, *Sinners and Citizens. Bestiality and Homosexuality in Sweden, 1880–1950*. Chicago & London: University of Chicago Press, 2003, p. 29, and Jens Rydström, "Introduction," in Jens Rydström and Kati Mustola (eds.), *Criminally Queer. Homosexuality and Criminal Law in Scandinavia 1842–1999*. Amsterdam: Aksant, 2007, pp. 25–27.
5. Tor Hedberg, *Minnesgestalter*. Stockholm: Bonnier, 1927, pp. 128–129; Prince Eugen, "Konstnärsförbundets män. Minnen och intryck," in *Ord & Bild*, 1936, p. 467.
6. Greger Eman, "Bröderna Jansson," in Göran Söderström (ed.) 1999, pp. 229–235.
7. Several sketches are reproduced in Claes Moser, *Eugène Jansson. The Bath-House Period*, exhibition catalogue. London: Julian Hartnoll, 1983.
8. Dodo Parikas, "Stockholms soldaters hemliga liv," in Göran Söderström (ed.) 1999, pp. 522–524.
9. For an in-depth discussion on homoeroticism as a category in art history, see Michael Hatt, "The Male Body in Another Frame. Thomas Eakins' The Swimming Hole as Homoerotic Image," in *Journal of Philosophy and the Visual Arts*, 1993, pp. 8–21.
10. Gösta Adrian-Nilsson, *Konst och kritik. Ett svar från Gösta Adrian-Nilsson*. Malmö: AB Framtidens bokförlag, 1915, p. 18.
11. Nilsson 2015, p. 22.
12. 29.7.1917, diary No 3. GAN-arkivet, Lund, Lund University Library.
13. Jan Torsten Ahlstrand, "Storstaden och sjömännen. En studie i Gösta Adrian-Nilssons konstnärliga utveckling 1914–1920," in Pedro Westerdahl (ed.), *Gösta Adrian-Nilsson. Sjömanskompositioner: färgens dramatik och stadens dynamik*, exhibition catalogue. Stockholm: Sven-Harrys konstmuseum, 2019, pp. 29–30.
14. Jonathan Weinberg, *Speaking for Vice. Homosexuality in the Art of Charles Demuth, Marsden Hartley, and the First American Avant-Garde*. Yale: Yale University Press, 1993.
15. Clare Barlow (ed.), *Queer British Art 1861–1967*. London: Tate Publishing, 2017, pp. 139–141.

COASTAL SÁMI AND INDIGENOUS ATLANTIC OCEAN SKILLS

Camilla Brattland and Ove Stødle

In this essay, we—two coastal Sámi persons living by and entangled with the North Atlantic Ocean through our lives, experiences, and positions in local and university communities—narrate and reflect on the concept of coastal Sámi *árbevirolaš máhtu* (traditional skill) and other Indigenous traditions and practices connected to the ocean. The concept of *árbevirolaš máhtu* is closely related to but different from the concept of *árbevirolaš diehtu* (traditional knowledge).[1] A practitioner of Sámi traditional skills, a knowledgeable person, is an *árbečeahpi* (plural: *árbečeahppit*). Current Sámi policy place an emphasis on traditional Sámi skills over knowledge, as traditional knowledge cannot be disembedded from its practices such as traditional Sámi handicraft, fishing, hunting or other skills.[2] Growing up in coastal communities in the 1980s, the school curriculums and societal development policies placed little emphasis on the value of Sámi skills, nor were we taught a lot about Sámi history, language and culture. Thanks to local historians and *árbečeahppit* who documented and preserved knowledge of Sámi languages, culture and history, we were able to learn about Sámi skills embedded in terminologies and knowledge of marine seascapes and species, about Sámi handicraft and boat-building. We think that traditional skills are important also for other Indigenous peoples from the North Atlantic Coasts, such as with Greenlandic Inuit. One example of an ocean skill is the ability to navigate stretches of ocean using a rich terminology for sea bottom features and knowledge of the seascape. Other examples are skills that were silenced by the Norwegianization policy and changed during modernization, such as traditional coastal Sámi handicrafts utilizing fish skin and marine mammals, and boat-building skills.

SILENCING SÁMI OCEAN SKILLS IN HISTORICAL NARRATIVES

Historical sources tend to silence the presence and expertise of Indigenous peoples in journey accounts of crossing the North Atlantic Ocean. Norse and Viking explorers were presented as the main actors of exploration and as having seafaring skills and abilities.[3] Both the Greenlandic and northern Norwegian coasts were explored,

settled and colonized by Norse seafarers and explorers around the beginning of the first century A.D. The well-known account of Ottar to the Anglo-Saxon king Alfred from the year 890 is one of the first historical sources describing the northern part of the European coasts as inhabited by Sámi.[4] The Greenlandic coast was explored in the late 900s by Eirik Raude (Erik the Red), who left behind settlements on the eastern and western coasts of Greenland. In a wider perspective, the narrative is dominated by the European explorers during the so-called Age of Discovery in the 15th and 16th centuries which established the sea route to the Americas and other continents. This eventually opened the doors to the colonization of the Americas and to the North, and to the exploitation and even extinction of Atlantic Ocean species, such as whales. Sámi were also known as skilled whale hunters, and remnants of the position of the whale in Sámi and North Atlantic coastal cultures can be evidenced from whale bones in archaeological grave finds and on rock carvings along the northern Nowegian coastline.

During the colonial and nation state building periods, European perceptions of the lack of skills of Indigenous peoples made the idea of direct relations between the Sámi and the Inuit across vast ocean distances unthinkable. Yet, the similarities in adaptation to the Arctic and marine environment that can be found in languages, sewing skills, rituals, knowledge of species and place names, raise the question of what kind of relations were already established between coastal peoples along the north Atlantic coasts. Little is known of the boat-making and navigational skills of Sámi and Inuit peoples who already inhabited the northern Atlantic coasts and with whom the Norse exchanged goods, skills, and developed trade networks. In early historical accounts, the Sámi were recognized as skilled skiers,[5] while Greenlandic Inuit were known for their navigational skills through the use of the *kayak*. The Vikings however knew Sámi as skilled boat builders from whom they commissioned both fast, small boats and freight vessels. In the Viking Sagas (10th and 11th century), Snorre Sturlason and Eirik Oddsson tell of coastal Sámi people who built large boats. These were not clinker-built but lashed together with tendons which was a Sámi traditional boat-building practice.[6] According to the Viking Sagas, the ship "Ormen," (the worm) which "Radu den Rame" in Salten had built, is considered to be either entirely or partially constructed by Sámi.[7] The Swedish bishop Olaus Magnus also included an illustration of Sámi boat builders in his work on the history of the Nordic peoples, *Historia de gentibus septentrionalibus*, published in Rome in 1555 →FIG. 72. In addition to the Viking saga accounts, archaeological findings support that the Sámi were skilled boat builders already in the Iron Age or early Middle Ages.[8] The historian Alf Ragnar Nielsen document key sites where Sámi boats were built along the northern Norwegian coastline, based on historical sources such as the presence of boat-building equipment in the coastal Sámi tax records from the 1600s, pointing to records of Sámi boat-builders along the entire coast from Vesterålen to the Varanger fjord.[9] Sámi fishers participated in the seasonal Lofoten fisheries with their own boats and using their own equipment and also feature in the watercolor landscape paintings of Lofoten by the artist Hans Johan Frederik Berg (1860s and '70s) →FIG. 26.

PRACTICING TRADITIONAL SÁMI AND INDIGENOUS OCEAN SKILLS

Many of the coastal Sámi traditions and skills are documented by the *Mearrasiida* (sea home area) center in Porsanger, collected through interviews with Sámi fishers and knowledge holders in the area.[10] As part of the work of *Mearrasiida*, revitalization of traditional wooden fishing boats (*spissá*) is currently one of the key

activities of the center.[11] Several wooden boats have recently been constructed under the mentorship of boat-builder Hans Oliver Hansen. In the making of boats, Sámi terminology for boat parts and the technology behind boat construction is revealed. The Sámi boat-building tradition is also part of the family of traditional Nordic clinker boat-building practices (wooden boats held together with metal clinkers). In historical and archaeological sources, Sámi were known for utilizing sinew from reindeer or other animals, or other material for sewing the wooden boat parts together. The use of sinew for making of rope and other materials from marine mammals or other animals is also a skill known in the making of Greenlandic *kayaks* and for sewing clothes made from animal skin. We see similarities between Sámi and Inuit methods for making footwear made out of sealskin, where the same type of seal species hide was used for making the bottom of the footwear and some sewing techniques that are used for making the Sámi *čázehat* (or *komager*) are also found in the making of the Inuit *kamiks*. Both of these waterproof shoes are made from a particular type of seal, and there are also similarities in the tanning and conserving procedures for the footwear between the Sámi and the Inuit. The main difference is the shape of the shoes, where the Sámi shoes are made with a tip for fitting the shoe with skis during winter → FIG. Q.

A related example is skills related to making of clothing and other products out of fish and marine mammals. The making of semi-transparent material out of halibut as a particular coastal Sámi skill illustrated by the artist Joar Nango's work *Skievvar* (2019) → FIGS. 80, 81. To make this large-scale sculptural work, Nango has in collaboration with a *duojár* (Sámi handicrafter) sewn together carefully dried and prepared halibut stomachs to make a screen, on which an ambient video is projected. Nango's use of halibut is mirrored in the making of Greenlandic waterproof clothing made from seal and marine mammal intestines. The Inuit were also known as skilled navigators with their own Indigenous navigation system using miniature carved models of the coast as navigational devices during boating. These historical accounts and remnants tell of Indigenous skills that were probably shared across and between cultural and geographical boundaries. Such navigational methods and the use of marine mammal and fish intestines are examples of advanced technologies and skills for surviving in harsh Arctic and coastal conditions.

FIG. Q Photo of Sámi *čazehat* and Inuit *kamiks*. Photo: Mearrasiida/Ove Stødle.

One of the skills that still remain visible and which we both learned while growing up on the coast, is navigation towards fishing-grounds using landmarks and toponyms. The presence of Sámi marine terminology and especially use of marine toponyms for navigating open expanses of sea testifies to the skills and knowledge of Sámi as seafarers and explorers in north Atlantic waters. Similarly to marine navigational practices of coastal peoples worldwide, also the Sámi used landmarks (in Sámi language: *bivdomearkkat* or *vihtat*), a juxtaposition of features on land, to locate fishing-grounds or other significant points on the water surface while boating → FIG. R. Some of the locations are handed down orally, and some are marked down in written sources and on sea charts. The Porsanger fjord is a seascape scattered with islands, small inlets, and shallows, and holds more than eighty named places in Sámi language referring to the characteristics of the sea bottom such as shallows, ridges and depths. One of the toponyms, Fáhccabealli, refers to the fish halibut, indicating that halibut was once an important species in

Olggos: Guovdesuolu luovvana Jágánis
(Hamnholmen løsner fra Trollholmen)

Veasttas: Elle Máret viessu birra Fáškkasnjárgga
(Elle Máret sitt hus rundt Fáškusnjárga)

FIG. R Drawing made by Sámi *árbečeahppi* Hans Oliver Hansen, describing the landmarks to the fishing ground Fáhccabealli.
The text in the figure in English: Outwards: The island Guovdesuolu breaks loose from the peninsula Trollholmen. To the west: The house of Elle Máret around the peninsula Fáškusnjârga. Credit: Hans Oliver Hansen and Mearrasiida.

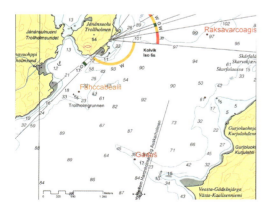

FIG. S Excerpt from a Norwegian Sea Chart, printed in Brattland and Nilsen 2011 with permission from the authors. Norwegian Map Authority, Sea Chart Map Series, map no 106. downloaded in 2010. Licence CC BY 4.0. Photo: Camilla Brattland.

what is now an area empty of flatfish due to changes in climate and biodiversity. Halibut is a North Atlantic species that is important also in Greenland.

The name itself, Fáhccabealli, refers to "half of a pair of mittens," referring to the shape of small halibut. The Norse name for the halibut refers to it as a holy fish, and it is still a prized Christmas dinner food with its high content of marine fat. The Sámi name for the halibut, *bálddis*, is similar to the Norse name *balda*. To use these "holy" names meant bad luck, and especially during fishing the fish should be referred to in other ways, such as in the example of "fáhccabealli."

Another example is the toponym Fáhcconcoagis ("mitten fishing-ground") which is a fishing ground in proximity to the one first mentioned. One of its landmarks refer to the mountain Fáhccon which is far away from the site itself, but which can be gleaned from the site and which gives direction to the sailor who wants a safe course between islands and shallows. In this case, one might wonder if the mountain was named based on its function as a landmark to the halibut fishing area, or if the fishing ground received its name from a mountain looking like a mitten from the position of the viewer. The Jåks sculpture *Liten Háldi* (*Little Háldi*, 1996) (in English: small mountain) → FIG. 53 —a miniature figure poetically combining different shapes, surfaces and materials—gives associations to relations between mountains and boats in Sámi cultural practice, as the toponym "háldi" is commonly used for mountains with a spiritual significance. To our eyes, the sculpture looks like a small white boat with a black slab of mountain rock (in the sculpture the mountain is made out of ironwood) resting inside. In Sámi spiritual practice, the use of iron also holds a special spiritual significance. Together with the name "háldi," for us this reminiscences the connection between the boat and the mountains merged together in one, simultaneous, sculpture. The presence of Sámi toponyms were silenced in Norwegian sea charts as a result of the Norwegianization policy[12] but has since the 1990s seen a resurgence due to the work of local Sámi *árbečeahppit,* cultural workers and researchers to vitalize local Sámi language and cultural practices related to the seascape.[13] In → FIG. S, this silencing is illustrated with the Norwegian name "Trollholmgrunnen" (Troll fishing-ground) which here is used instead of Fáhccabealli, the name known for the same fishing-ground by Sámi *árbečeahppit*. With the preservation of Sámi toponyms in sea charts, some of the knowledges and skills related to Sámi ocean navigation are preserved.

PRESERVING SÁMI TRADITIONAL SKILLS FOR SUSTAINABILITY

The increasing industrialization and modernization of the fisheries after the World War II and introduction of the market economy which took hold from the 1980s onwards radically changed the knowledge and practice of traditional fjord fisheries. An example of the effects of this regime are the wrecks of traditional wooden fishing boats lining the shores of Porsanger, boats that were once used for harvesting fish in the inner part of the fjord system. Whereas these wooden boats were used for decade after decade, modern fishing vessels are more quickly decommissioned due to changes in fisheries policies for boat length or storage capacity. The current fishing fleet is dominated by coastal fishing vessels with outboard engines and state of the art fish-finding equipment (radar and sonar), while the traditional boats used sail and oar technology coupled with local and traditional knowledge and skills of the seascape and its landmarks to navigate the fjordscape as part

of a sustainable fishing management practice. With the changes in the type of boat used for fisheries, the traditional knowledge system has lost its relevance in favor of reliance upon digital and mechanical fish-finding equipment.[14] This is not to say that traditional seascape practices have disappeared, but that resource management practice where traditional skills and knowledges are required, are currently exercised for subsistence and recreational purposes and not dominantly for commercial purposes.

The traditional Sámi naming practices and utilization of fish and animal skin and hides are part of a coastal Sámi resource management approach, which we as coastal Sámi persons think it is important to remember and take care of. The knowledges and skills of navigating seascapes by the use of wooden boats adapted to the local environment, built by local boat-builders, and utilizing the Sámi names, terminologies and skills related to fishing and navigation, are quickly disappearing. Taking care of Sámi terminologies and languages, and their related traditional skills, is important. Taking care of resources is also a traditional skill—*Sámi árbevirolaš máhtu*. Such a resource management approach is evident for example in how the coastal Sámi in the Porsanger fjord take care of the seascape with its islands and fishing-grounds despite radical biodiversity change since the mid-1980s. Caring for eider ducks and other sea birds nesting on islands in the fjordscape, whose eggs and down used to be harvested by the local population, exemplifies this approach. This form of resource management implies ensuring a balance between birds and its predators such as foxes, and to make certain there is enough small fish in the ocean to feed the bird families. This could also be called *vuotnadikšun*, fjordscape caring practices, similar to the Sámi caring practices for lakes, *jávredikšun*, described by Liv Østmo and John Law for the Guovdageaidnu region.[15] Such traditional nature (in Sámi language: *meahcci*) caring practices and skills, stand in contrast to national resource management regimes, where quotas and temporal measures regulate the use of the ocean.[16]

REFLECTING ON THE BOUNDARIES BETWEEN SKILLS AND KNOWLEDGE

An important reflection has emerged from our journeys of uncovering and discovering coastal Sámi and Indigenous traditions, knowledges and skills of the ocean. This is gained from historical sources and our engagement with *árbečeahppit*, but also from research conducted both in local knowledge and language centers, and at the university. In light of the current national and global emphasis on the importance of including traditional, Indigenous and local knowledges in the basis for sustainable management and development, we experience that this is increasingly included by both Indigenous and non-Indigenous research. More importantly, the accessibility of higher education and open dissemination of historical and cultural research has enabled Sámi to partake in, discuss and contribute to the scientific knowledge production of their own culture and to research disciplines not only in the social sciences and humanities, but also in marine science. Knowledge is however not the same as skill, and to also include the practice of skills in research is needed. We see that Indigenous artists, architects, handicrafters, and cultural workers pay attention to the importance of skill through their work, such as in the practices of Joar Nango and Iver Jåks. In order for Indigenous skills and art to be recognized, however, there is a need to break out of confining understandings of knowledge, skill, craft, and technology as separate categories.

If knowledge was conceptualized as part of skill, what would be the implications for how we understand Indigenous and scientific knowledge and their

boundaries and similarities? The examples we have referred to cannot be reproduced through the same knowledge production systems as in universities, where the main skillset is related to writing, thinking, analysis and reflection. To exercise skill, much more than thinking and writing is needed, such as bodies, materials, nature, community, learning across generations, interactions with the environment, and a language that can encompass and describe both environment and humans in exactly the ways that are needed to exercise the skill in question. In essence, we argue for a development where knowledge and skill should not be kept apart, and where new figures might emerge as mixtures between Indigenous artists, *árbečeahppit,* cultural practitioners, and scientific knowledge producers embedded within varying academic and community roles and positions.

Endnotes

1. Gunvor Guttorm, "Árbediehtu (Sami traditional knowledge) – as a concept and in practice," in Jelena Porsanger and Gunvor Guttorm (eds.), *Working with Traditional Knowledge: Communities, Institutions, Information Systems, Law and Ethics*. Sámi Allaskuvla, Guovdageaidnu: Dieđut 1, 2011, pp. 59–73.
2. Sámediggi 2021, *Máttuid árbi boahtteáigái* (Sámi Parliament, *Report on Sámi traditional skills*) [website], https://sametinget.no/_f/p1/i50da2bc0-d0d1-4dc9-b3b9-3e3efaf0cebd/mattuid-arbi-boahtteaigai (accessed 20 January 2024).
3. Stephen Wickler, "Submerged cultural heritage and ethnicity in northern Norway: visualizing Sami waterscapes from an archaeological perspective," in *Varanger Samiske Museums Skrifter*, no. 6, 2010, pp. 117–131.
4. Lars Ivar Hansen and Bjørnar Olsen, *Hunters in transition: An outline of early Sámi history*, The Northern World, vol. 63. Leiden: Brill, 2013.
5. The term "skridfinner" for Sámi in medieval European journey accounts refer to the ability to ski, as noted by Hansen and Olsen 2013.
6. Sirpa Aalto and Veli-Pekka Lehtola, "The Sami representations reflecting the multi-ethnic North of the saga literature," in *Journal of Northern Studies*, vol. 11, no. 2, 2017, pp. 7–30.
7. Snorre Sturlasson, *Kongesagaer*, trans. Anne Holtsmark and Didrik A. Seip. Oslo: Gyldendal, 1975.
8. Wickler 2010.
9. Alf Ragnar Nielssen, *Samisk fortid i Lofoten*, Museum Nords skriftserie no. 2. Melbu: Orkana Forlag, 2022.
10. *Siida* is a Sámi term for a resource area within which Sámi moved between seasonal dwellings.
11. Mearrasiida, *Båter og båtbygging* [website], https://mearrasiida.no/index.php/bater-og-batbygging-ny (accessed 20 January 2024).
12. The Norwegianization policy was enacted by the Norwegian state to assimilate minority and Indigenous cultures into a homogenous Norwegian nation state, lasting from the 1850s to after the World War II.
13. Camilla Brattland and Steinar Nilsen, "Reclaiming indigenous seascapes. Sami place names in Norwegian sea charts," in *Polar Geography*, vol. 34, no. 4, 2011, pp. 275–297.
14. Camilla Brattland, "A cybernetic future for small-scale fisheries," in *Maritime Studies*, 13, 2014, pp. 1–21.
15. Liv Østmo and John Law, "Mis/translation, Colonialism, and Environmental Conflict," in *Environmental Humanities*, vol. 10, no. 2, 2018, pp. 349–369.
16. Camilla Brattland, Bente Sundsvold and Svanhild Andersen, "Knowing and Caring about the Future Porsanger Fjord Back to Life," presentation at the conference "Landscape Practices Conference," Kautokeino, Norway, 2022.

ARNE EKELAND
NICOLAUS GERMANUS
FRIDA HANSEN
THOROLF HOLMBOE
MARIE KØLBÆK IVERSEN
EUGÈNE JANSSON
JOAN JONAS
IVER JÅKS
THEODOR KITTELSEN
JESSIE KLEEMANN
CHRISTIAN KROHG
PER KROHG
EMILE LASSALLE, AFTER AUGUSTE MAYER
BARTHÉLÉMY LAUVERGNE
ARMIN LINKE
JAN HUYGEN VAN LINSCHOTEN

WORKS

WE-LKS

FIG. 42 *Lofoten Fishermen*, 1935
Oil on canvas
SpareBank 1 Nord-Norges kunststiftelse, Tromsø
Photo: SpareBank 1 Nord-Norge/Håkon Steinmo
© Arne Ekeland/BONO 2024

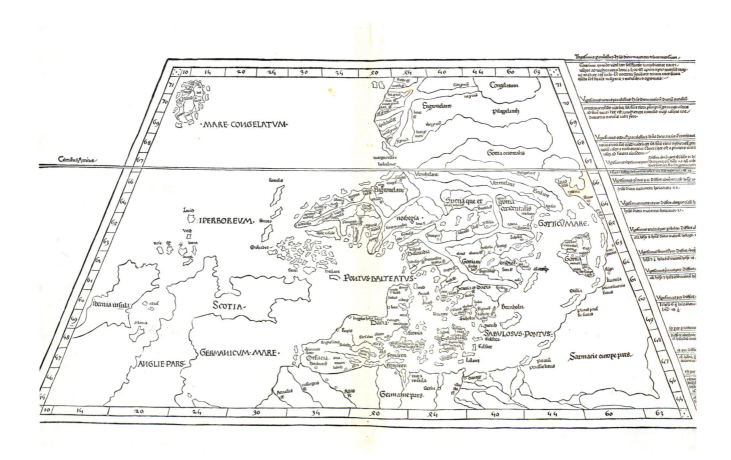

FIG. 43 *Scandinavia Map*, from *Ptolemy's Geography*, Ulm, 1482
Woodcut on paper
Nasjonalbiblioteket, Oslo
Photo: Nasjonalbiblioteket

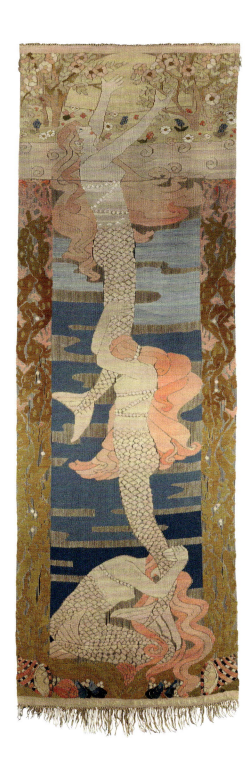

FIG. 44 *Mermaids*, 1921
Tapestry
Stavanger kunstmuseum, Stavanger, deposited by SpareBank 1 SR Bank
Photo: Dag Myrestrand/Bitmap

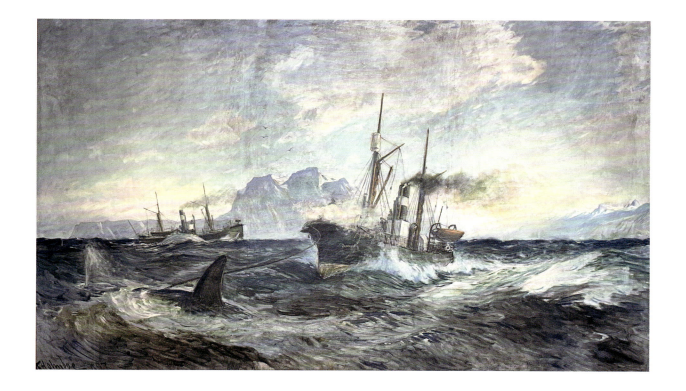

FIG. 45 *Duncan Gray and Nancy Grey Whaling*, 1897
Oil on canvas
Schøyensamlingen, Asker
Photo: Eva Sneve

FIGS. 46–47 *Histories of Predation*, 2022
Video
Installation view, O—Overgaden
Courtesy the artist
Photo: Laura Stamer

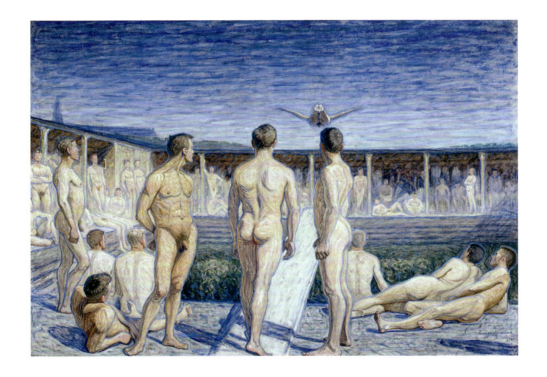

FIG. 48 *Bath House Scene*, 1908
Oil on canvas
Örebro kommuns konstsamling, Örebro
Photo: Örebro kommuns konstsamling

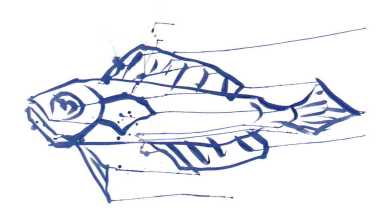

FIGS. 49–52 *they come to us without a word*, 2013–2023
Prints of ink drawings on paper
Courtesy the artist
© Joan Jonas/BONO 2024

FIG. 53 *Little Háldi*, 1996
Horn, turtle shell, ironwood
KORO (Public Art Norway), Oslo
Photo: KORO/Guri Dahl
© Iver Jåks/BONO 2024

FIG. 54 *The Draug – the Ghoul of the Sea*, probably around 1880
Ink, pencil and watercolor on paper
Nordnorsk Kunstmuseum, Tromsø
Photo: Nordnorsk Kunstmuseum

FIGS. 55–57 Stills from *Arkhticós Dolorôs*, 2019
Video (HD), with sound
Courtesy the artist

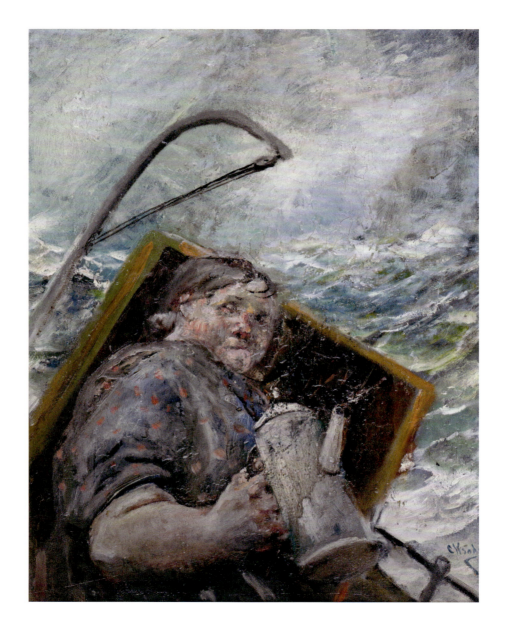

FIG. 58 *Waitress at Work*, 1901
Oil on canvas
Nordnorsk Kunstmuseum, Tromsø
Photo: Nordnorsk Kunstmuseum/Kim G. Skytte

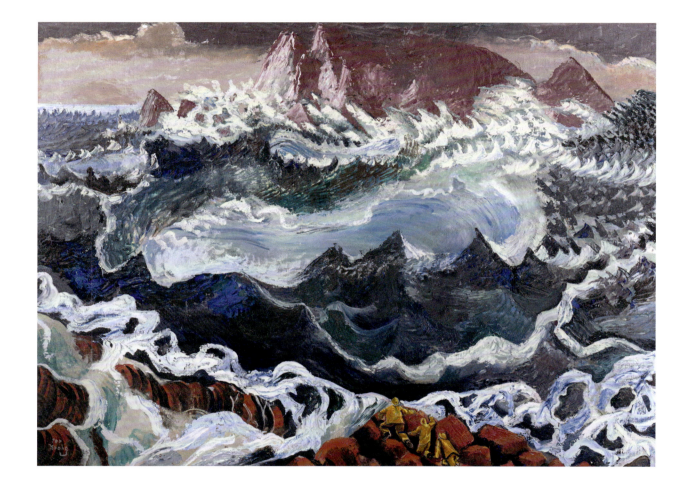

FIG. 59 *The Maelstrom*, 1929
Oil on canvas
Nordnorsk Kunstmuseum, Tromsø
Photo: Nordnorsk Kunstmuseum/Kim G. Skytte
© Per Krohg/BONO 2024

EMILE LASSALLE, AFTER AUGUSTE MAYER

FIG. 60 *Hornvika east of Nordkapp*, between 1842 and 1856
Hand-colored lithograph on paper
Nasjonalmuseet for kunst, arkitektur og design, Oslo
Photo: Nasjonalmuseet/Andreas Harvik

FIG. 61 *View from Smeerenburg Bay*, published 1852
Litograph on paper
Nordnorsk Kunstmuseum, Tromsø
Photo: Nordnorsk Kunstmuseum/Kim G. Skytte

FIG. 62 *The 22nd Session of the International Seabed Authority Assembly ISA, Kingston, Jamaica, 2016*

FIG. 63 *RWTH Aachen University, AMR Unit of Mineral Processing, mineral nodules section under a microscope, Aachen, Germany, 2017*

FIG. 64 *International Seabed Authority (ISA), manganese nodule, Kingston, Jamaica, 2016*

FIG. 65 *International Seabed Authority (ISA), Office of Legal Affairs, Kingston, Jamaica, 2016*

FIG. 66 *NTNU (Norwegian University of Science and Technology), Department of Marine Technology, Trondheim, Norway, 2016*

FIG. 67 *Protest against deep-sea mining project in the Bismarck Sea, Karkar Island, Papua New Guinea, 2017*

FIG. 68 *NTNU (Norwegian University of Science and Technology), Department of Marine Technology, ocean basin laboratory, Trondheim, Norway, 2016*

All works from the project *Prospecting Ocean*
Lambda print
Courtesy the artist

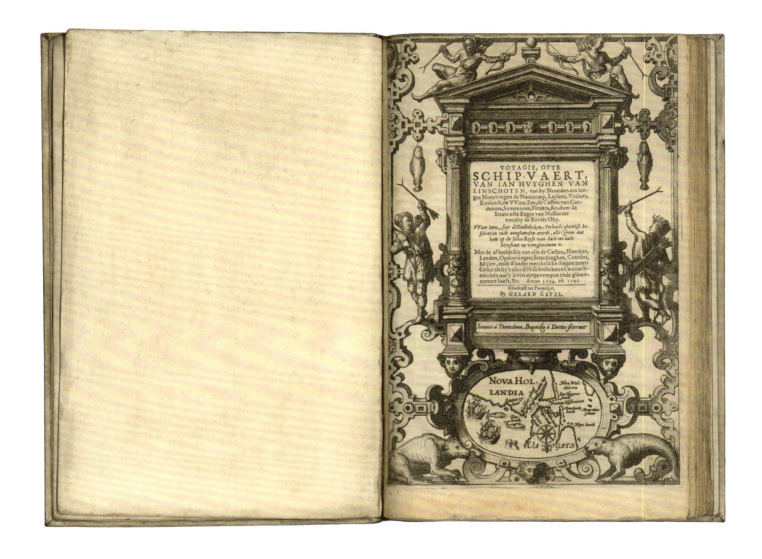

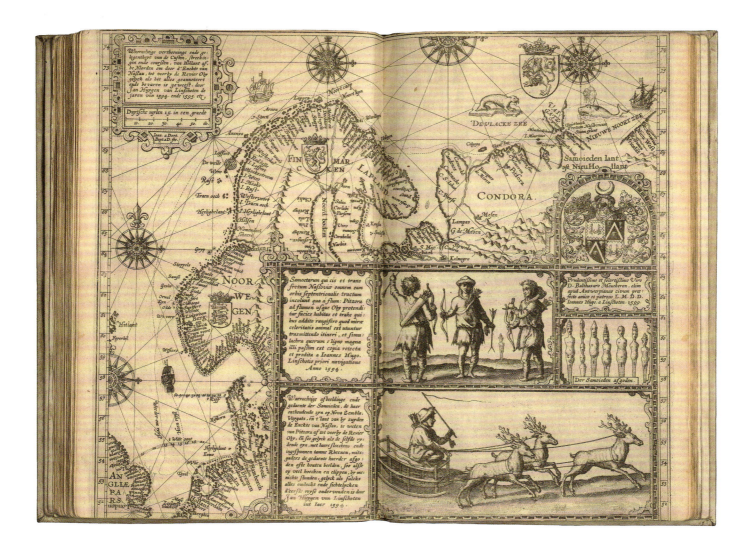

FIGS. 69–70 *Voyagie, ofte schip-vaert ... van by Noorden om langes Noorvegen de Noortcaep, Laplant, Vinlant, Russlandt ...*, 1601
Nasjonalbiblioteket, Oslo
Photo: Nasjonalbiblioteket

ANNA BOBERG'S LOFOTEN PAINTINGS

Martin Olin

In the summer of 1901, Anna Boberg (1864–1935), a Swedish artist in her mid-thirties, visited the Lofoten islands off the northwest coast of Norway for the first time. She was so taken with the light and the majesty of the mountain range rising out of the sea, that she could not force herself to leave. She wrote later that she had come under a spell, and that all she wanted was "to stay and paint, paint, paint."[1] Her husband, the architect Ferdinand Boberg (1860–1946), returned to the mainland and sent her the necessary painting equipment. She came back to Lofoten seven months later, in the middle of the winter of 1902, to paint, and would return more than twenty-five times during the following decades, until her death in 1935. The Bobergs constructed a cabin on a cliff on Fyrø by the inlet to Svolvær that served as a place to sleep and work. During arduous and at times dangerous expeditions on foot and in small boats, using portable easels, she captured views of the sea and the mountains in oil sketches on cardboard, which she later reworked in her studio, transferring the subjects to larger canvases.

A SWEDISH PAINTER IN LOFOTEN

Anna Boberg exhibited her Lofoten paintings for the first time in Stockholm in 1903. The reviews were mixed, but one was to make a lasting impression, a damning article by the powerful president of the Artists' Association (Konstnärsförbudet), the landscape painter Karl Nordström.[2] Anna Boberg was disappointed but not discouraged. In 1905, she showed her works in a private gallery in Paris. At first, the show had no impact and only a small audience, but then the situation changed. In an open letter published on the first page of the daily paper *Le Gaulois*, France's greatest actress Sarah Bernhardt recommended the exhibition in the most passionate language, imploring the audience to visit it, describing how she had first visited Anna's studio where her initial curiosity "turned into humble admiration, for her work is beautiful and rich in feeling, full of surprise and audacity... Come and see Anna Boberg's works."[3] These ardent words seem to have had the intended effect. Critics arrived to see the show, and it received many positive reviews, starting with

a two-column article by François Thiébault-Sisson in *Le Temps*. Between 1905 and 1927 Anna Boberg had five solo exhibitions in Paris and was represented at the Salon many times.[4] Her work was shown in Berlin and London. It was exhibited in the United States, where it attracted considerable attention.[5] She was invited to show her Lofoten paintings at the Venice Biennale together with other painters several times from 1907. The Italian National Gallery purchased her *Vikinghi moderni* ("modern Vikings"), showing a fishing boat with red sails forcing its way through the waves. In 1912, she was the sole exhibitor in the new Swedish pavilion in Venice. Her work was awarded prizes; reviews were almost always positive.

Boberg's Lofoten landscapes (she rarely painted other subjects) caught the imagination of an international audience for whom they were compelling visions of a distant and sublime North. A few phrases from Thiébault-Sisson's review of her 1910 show at the Galerie Durand-Ruel may exemplify the reception of both the paintings and of the intrepid painter: "Paying the price of ceaseless difficulties, persistent but overcome by a determined will, she has studied, as the seasons pass by, the most varied phenomena, the most shifting skies, the most staggering light effects that can be seen: moonlit nights and northern lights, blasts of rain, snow and ice, storms and lulls, dawn and dusk, midday darkness and midnight sun."[6]

BOBERG IN HER OWN WORDS

The account of Anna Boberg's outset as a landscape painter in Norway is often told more or less along these lines. It is she herself who has structured the story, beginning with the first visit in 1901 when she was mesmerized by the sea, the wind and the mountains (*havet*, *vinden*, *fjället*—"Lofoten's Three Great Ones") and continuing with her twice-yearly pilgrimage to find freedom to create in a rapturous confrontation with the elements, shedding the comforts of life in the city but supported by the kindness of the rough locals and her own good humor.[7] Boberg published her account in the opening section of her 1934 autobiography, *Envar sitt ödes lekboll* (the title may be translated as "Each and one of us the playthings of our destinies"). It is well narrated, and perhaps, the reader suspects, she has told the story many times before—to journalists and critics, to friends and new acquaintances curious to know how it all began. The autobiography is a rhapsodic but deliberately phrased book, written in a modified version of the ironic, mock-declamatory style used by the author in letters and diaries, typical of its time and typical of its prejudices. As other written sources to Anna Boberg's Lofoten sojourns are rare, the autobiography, although in many ways a staged, literary text, is important. Normally a prolific letter-writer, she seems to have put off correspondence until she was about to leave Lofoten or was actually on her way back to Stockholm. She would then write a post-card with a photograph of a Svolvær view and a few lines about the weather during the visit and her planned route for the return journey. During her winter visit in 1905, however, meteorological circumstances prevented Boberg from painting outside, which prompted an exceptional letter to her sister Maria Hedlund: "Surprise! I'm corresponding. Haha! I'm sitting here, without no alternative, the captive of the storm on my island."[8]

FIG. T Anna Boberg in her studio at Vintra, Stockholm, ca. 1910.
Photo: Nationalmuseum, Stockholm.
A similar photo was published in the Italian journal *Emporium* in March 1911.

The raging elements did not, as we learn later on in the letter, prevent her local servant girl from coming in and serving tea. Boberg also describes how she tried going out in her boat in the harbor during a lull in the storm, bringing her painting equipment, but that she had to be helped ashore when the wind suddenly returned → FIG. U.

NORTHERN LIGHTS AND FISHERY: BOBERG'S SUBJECT-MATTERS

In a number of spectacular paintings from Lofoten, Anna Boberg depicted the phenomenon *aurora borealis*—northern lights, which occurs when solar winds cause charged particles to crash into the atmosphere → FIG. 31. The resulting greenish, flickering lights occur close to the magnetic poles. In the Arctic, there are frequent possibilities to study it, but *aurora borealis* was a very rare subject in art before the 20th century, presumably as few artists worked in the Arctic region during winter. In the autobiography we first read about her observing it when she went out in a boat during the night with the fisheries supervisor, on the lookout for illicit fishing. A more elaborate description follows the paragraph relating the inauguration of the Fyrø cabin on New Year's Eve of 1902, when the Bobergs stepped outside at midnight: "After having performed the dance of veils à la [the American dancer] Loïe Fuller, the northern lights exploded in thundering, glorious fireworks until the entire firmament was ablaze. At the top was, as in the Pantheon in Rome, a large, window-like opening at the edge of which the flames suddenly stopped, allowing us to perceive the dark night above the burning dome."[9] Boberg says that she never again saw the northern lights as magnificent as on this occasion, and although her paintings from this period generally are difficult to date, it may be assumed that her first paintings of *aurora borealis* were conceived in the early hours of 1903.[10]

Less immediately dazzling are Boberg's paintings of subjects related to fishing. She often emphasized how awe-inspiring and moving she found the view of the many hundreds of fishing boats going out to sea or coming home with their catch. During her first years in Lofoten, the traditional boats with their red sails appear in her paintings, frequently referred to in her writings and in the titles of the paintings as reminiscent of (or even reincarnating) the ships of the Vikings → FIG. V. Although a tranquil view of moored boats and wooden buildings by a steep mountainside, *After the Massacre* → FIG. 30 refers to the killing and gutting of tens of thousands of cod during a day of fishing, when the water of the harbour turned red and oily from blood and fish entrails, described by Boberg in her book. Perhaps the red brushstrokes around the rock in the middle of the harbour are intended to remind the viewer of the slaughter. Interestingly, the label of the picture retains the French title, *Après le massacre*, under which it must have been presented to a Paris audience. A section of the autobiography describes how Boberg accompanies a fishing boat during a day in February 1902, commenting not only on the visual aspects but also on the social and economic realities involved in the cod fishing industry, a subject about which she clearly knew much more when writing in 1934 than when first experiencing it. One of her last Lofoten paintings is the crepuscular scene *Svolvær Harbour during the Fishing Season*, where the electric lights suggest the arrival of modern times.[11]

FIG. U Anna Boberg in Lofoten.
Photo: Nationalmuseum, Stockholm.

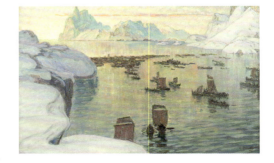

FIG. V Anna Boberg, *The departure of the fishing fleet*, n.d. Oil on canvas.
Photo: Nationalmuseum, Stockholm/ Linn Ahlgren

BOBERG AND HER TIMES: CONTEMPORARY RECEPTION AND ARTISTIC CIRCLES

Anna Boberg was thus a famous and celebrated painter—abroad. In Sweden, however, the art establishment resented her success and tried to ignore her. It was said that she had bought the foreign critics. Anna much later wrote in her diary about her first participation in the Venice biennale: "Happy, but full of apprehension, I shared the gallery with [Anders] Zorn, [Bruno] Liljefors and [Carl] Larsson. No wonder that those at home were scandalized, and of course it was wrong. It was a great success, however, and the Italians never noticed that one of the four sheep was black".[12]

Why was Anna Boberg ignored in Sweden? Bizarre neglect or blatant misogyny? Likely a bit of both, but that's not the whole picture. Boberg's exclusion, until quite recently, from Swedish art history writing is an interesting piece of art history in itself, not just a case of prejudiced neglect. In one way, Anna Boberg was an outsider when she had her first international successes. As a painter she was self-taught (or so she claims). The lack of formal training and absence of the camaraderie and networks that normally form during an academy education certainly explains aspects of her exclusion. But in most other ways she was an insider—*too much of an insider*, to be precise. Anna's father Fredrik Wilhelm Scholander was a professor of architecture and the secretary of the Royal Academy of Fine Arts. Her maternal grandfather had also been a prominent architect. She grew up in the house of the Academy and her father and grandfather had both worked for the royal family. The Scholanders had close ties with France, and in her youth, Anna lived in Paris in the family of Charles Garnier, the architect of the Paris opera. Her French became fluent, and she cultivated the conversational skills and the sharp and sometimes biting wit that would become one of the dominating traits of her personality. It was through Louise Garnier that Anna Boberg had been introduced to Sarah Bernhardt.[13]

Anna's well-connected family helped establishing her husband Ferdinand Boberg, whose career soon took off and established him as Sweden's leading architect. He designed the buildings for the Stockholm exhibition of 1897 and the Swedish Pavilions for the world fairs in Paris in 1900 and in St Louis in 1904. Through Ferdinand's work for the international exhibitions, the Bobergs had an international network that many of their Swedish colleagues lacked. It was one of their friends, the Italian politician and secretary general of the Venice biennale, Antonio Fradeletto, who suggested that Ferdinand should curate the Swedish gallery at the biennale in 1905, after Fradeletto had failed to get in touch with the regular committee.[14] And it was Fradeletto who invited Anna to participate, after having seen some of her paintings in Berlin. Again in 1912, he turned to Ferdinand when the Biennale organization wanted the Swedes to construct a national pavilion → FIG. W. Ferdinand supplied the plans, and the pavilion was constructed in short time and finished just before the exhibition, where Anna Boberg's Lofoten paintings were shown to great acclaim in the Italian press.

But in Sweden, influential artists resented Ferdinand Boberg's involvement in the Biennale, and were, as Anna well knew, furious about her being the chosen artist for the new pavilion in 1912. Leading members of the Artists' Association perceived Ferdinand and—in particular—Anna, as pushy and intended to stop their activities in the art world. Instead of Sweden taking over Boberg's pavilion, as had

FIG. W Swedish Pavilion, Venice Biennale, 1912. From the Biennale Archive. © Archivio Storico della Biennale di Venezia, ASAC.

been expected, it was acquired by the Netherlands the following exhibition. This was a terrible blow and the beginning of the end of his career as an architect.[15]

From another set of unusual circumstances followed privilege as well as isolation and jealousy: the Bobergs' close friendship with the royal family. They had become acquainted with Prince (Crown Prince from 1907) Gustaf Adolf and his British bride, Princess Margaret of Connaught, when Ferdinand was projecting a residence for them. Margaret was an amateur painter. She was shy and found it difficult to learn Swedish, and it was decided that she should paint together with Anna Boberg. They met weekly in the surroundings of Stockholm, painted, had tea, and spoke French together. Anna became a confidante. When Margaret suddenly died in 1920, the Crown Prince was distraught. Anna became a support for his family and the prince's closest female friend.[16] When Gustaf Adolf remarried, his second wife Lady Louise Mountbatten also took to the Bobergs, who became the royal couple's chosen travel companions. Loyalty with the Crown Prince and a fear of compromising him arguably excluded some choices Anna Boberg might have made as an artist. Their relationship also changed the way she was perceived by other painters.

The Crown Prince's uncle, Prince Eugen (1865–1947), was another close friend and the Bobergs' neighbor on Djurgården in Stockholm. Ferdinand had designed his residence, the villa-cum-gallery at Waldemarsudde. Anna and Eugen, also an artist, painted together in the vicinity, and the three saw a lot of each other privately.

Anna Boberg was a *grande dame*, a figure in society, always elegantly dressed and at home in Paris and Rome. Her own family were old art establishment: royal academy professors, court painters, court architects. It was against the academy and all it stood for that the painters and sculptors forming the Artists' Association had revolted in 1885. Her association with the old professors was not easily forgotten. She knew all the leading Swedish painters, but she was not one in their circle. Now, strangely, Prince Eugen was. He had spent time with the young Scandinavian artists in Paris in the 1880s, he sympathized with their artistic program and their radical politics. He was "the red prince." (Far from being reds, Anna and Ferdinand Boberg admired Mussolini, whom they met in Rome, and they were old friends since the Biennale days of the dictator's mistress, the art critic Margherita Sarfatti.) Despite their friendship, Prince Eugen remained critical of Anna Boberg's paintings, which to him were too far removed stylistically from the ideals of the Artists' Association. That he chose not to display any of her pictures in his gallery always pained Anna and embittered Ferdinand.[17]

PIONEERS IN DEPICTING LOFOTEN

Anna Boberg's art is more stylistically diverse than that of her Swedish contemporaries who relied mostly on French models (with an injection of Arnold Böcklin's saturated colors in the 1890s). The same is true about Betzy Akersloot-Berg (1850–1922), a Norwegian painter who settled in the Netherlands from the 1880s. She trained in Christiania (present-day Oslo) and later with her compatriot Otto Sinding in Munich, following the long tradition of artists dividing their time between Germany and Norway. From around 1885, she became an associate of the Dutch marine painter Hendrik Wilhelm Mesdag in the Hague, with her palette becoming paler, adapted to the gray North Sea skies of the Dutch coast. The shimmering light and glowing colors in Akersloot-Berg's view from Lofoten → FIG. 3, is an indication of its date in the early 1880s, when the painter spent the summers on the Norwegian

coast. The painting is a representative case of the Romantic, sublime landscape of the North—as conceptualized in the studios of Düsseldorf and Munich—with a barely noticeable presence of modernity in the form of a steamship on the horizon.

The light and the characteristic forms of the Lofoten islands, with their horizontal thrust and snow-clad mountainsides, return in some of the Swedish-Norwegian artist Anna-Eva Bergman's (1909–1987) paintings from the post-war period → FIG. 27. Bergman approached the nature and artifacts of Norway with a view formed in the midst of the European avant-garde, abstracting mountains, tombs, stones, ships, and celestial bodies into symbolic forms, often retaining their luminosity and a suggestion of materiality and surface structure. The spectacular Lofoten nature, with its space and light created by the dramatic topography, a position above the Arctic circle and the ever-present ocean cannot fail to thrill visitors, and for many of the visual artists who have made the journey during the last century, impressions have lasted.

Endnotes

1. Anna Boberg, *Envar sitt ödes lekboll*. Stockholm: P.A. Norstedt & Söners Förlag, 1934, p. 6.
2. *Svenska Dagbladet*, 7 March 1903, cited in Marianne Nyström, *Bobergs. Anna Scholander och Ferdinand Boberg*. Stockholm: Carlssons, 1992, p. 149. Nyström's double biography draws on a rich source material but is not particularly focused on art or architecture. For a recent discussion of Anna Boberg's paintings, see Isabelle Gapp, "An Arctic Impressionism? Anna Boberg and the Lofoten Islands," in Emily C. Burns and Alice M. Rudy Price (eds), *Mapping Impressionist Painting in Transnational Contexts*. New York and London: Routledge, 2021, pp. 90–102; Isabelle Gapp, "A Woman in the Far North: Anna Boberg and the Norwegian Glacial Landscape," in *Kunst og kultur*, årgång 104, nr. 2–2021, pp. 82–96. Katarina Macleod, Stockholm university, is currently working on a biography of the painter.
3. Cited in translation into Swedish in Nyström 1992, pp. 157–158; Boberg 1934, pp. 151–152, comments but plays down Bernhardt's influence and emphasizes that of Tiébault-Sisson.
4. A list of Boberg's exhibitions can be found in Karen Helén Andréassen, "'Lofoten fanget i et blikk'. Anna Bobergs malerier som representasjon av stedet Lofoten," Hovedfagsoppgave i kunsthistorie, vår 2002, Institutt for kunsthistorie, Humanistisk fakultet, Universitetet i Tromsø, pp. 111–115.
5. Eva-Charlotta Mebius, "'Sweden's Greatest Artist': The Reception of the Landscapes of Anna Boberg," in *Art Bulletin of Nationalmuseum Stockholm*, vol. 27:1, 2020, pp. 91–98.
6. A clipping of this review, headed "Choses d'art," is in Kungliga biblioteket, Stockholm, Handskriftssamlingen HS, L57:5. Author's translation.
7. Boberg 1934, pp. 5–15
8. Anna Boberg to Maria Hedlund, dated "sometime in March", with year later by Ferdinand Boberg, "probably 1905", Kungliga biblioteket, Stockholm, Handskriftssamlingen HS, L57:5.
9. Boberg 1934, p. 67. Author's translation.
10. A painting by Boberg called *L'aurora boreale* was exhibited at the Venice Biennale in 1907, see Dana Pernilla Stödberg, "Svensk konst genom italienska brillor. Svensk konst på Venedigbiennalen 1895–1907," D-uppsats i konstvetenskap, Stockholms universitet, 2005, p. 42.
I'm grateful to Pernilla Stödberg for sharing her material with me. In the catalogue of the Biennale, this painting is dated "Novembre 1905".
11. Dated 1934 on the verso by Ferdinand Boberg.
12. Anna Boberg's diary 25 April 1926, Kungliga biblioteket, Stockholm, HS, L 57: 24:1 (A reference to the Bobergs' acquaintance with Margherita Sarfatti is included in the same entry, see below). Anna Boberg specifically refers here to the exhibition in 1905, but there is no documentation of her participation in the official catalogues that year. Even though Boberg's memory may have failed her, the recollection is very specific, and a photograph in the fototeca of the Biennale Archive at Porto Marghera, Venice (fasc. 7, AV7:1905:20) appears to show one of her paintings in the company of works by the three mentioned painters. Her participation, in a limited way, could have been a last-minute addition, prompted by Fradeletto's (and her husband's) enthusiasm. For the reception of Anna Boberg in Italy, see e.g. Vittorio Pica, "Artisti contemporanei: Gustaf Fjaestad, Anshelm Schultzberg, Otto Hesselbom, Anna Boberg," in *Emporium*, vol XXXIII, March 1911, pp. 171–191 (for AB, pp. 182–191).
13. For these aspects of Boberg's biography, see in particular Nyström 1992, passim.
14. Boberg's correspondence (in Italian) with the organizers is in the Biennale Archive at Porto Marghera, Venice.
15. Marianne Nyström, "Ferdinand Boberg, Liljevalchs konsthall och Sveriges paviljong i Venedig," in *Konsthistorisk Tidskrift/ Journal of Art History*, vol. LXV, no 1, 1996, pp. 33–50.
16. Nyström 1992, pp. 245–247, and passim; Yvonne Gröning, *Fru Bob. En personlig biografi*. Stockholm: Gidlunds förlag, 2009, pp. 57–65.
17. See also Nyström 1996, pp. 47–50, with a nuanced interpretation of Ferdinand Boberg's views.

BUBBLES AS MEDIA IN OCEANIC ECOLOGIES

Melody Jue

Perhaps what is so poignant about bubbles is their possibility of bursting. In the medium of air, the child's fear and joy is that they might instantly destroy the floating sphere with the lightest brush of a dry finger. In the medium of the ocean, air bubbles are not so easily burst open because the surrounding pressure of water holds their form intact. Their ephemerality derives from the inexorable movement upwards, as they rush towards the surface of the sea before rejoining with the atmosphere. In the medium of glacial ice, air bubbles may be preserved for thousands of years as a record of past climates. Yet these ice bubbles, too, are ephemeral—when the climate warms, or the glacier fractures into icebergs in the sea. Although much has been written about the ontology of bubbles, attention should also be paid to their medium, and milieu, of encounter.[1]

Consider the role of bubbles in the 1976 film *Voyage to the Edge of the World* (*Voyage au bout du monde*), directed by Jacques Cousteau (1910–1997), who famously co-developed the first scuba diving technology, along with his son Philippe Pierre and Marshall Flaum. Towards the end of the film is a fantastical sequence where an all-male scuba team dives underneath an immense floating iceberg, poetically narrated by his late son Philippe. In this "palace of ice," the dive team encounters a sword-like protrusion and "sheaves of air bubbles, like showers of diamonds" that also shine "like pearls, stars, or comets." For Philippe, it is as if the iceberg were a magical castle full of long-lost treasures, hidden in a labyrinth of passages illuminated by light diffracting from so many frozen surfaces. Yet bubbles also stream from the divers' regulators, past the camera and to the surface of the ocean, or sometimes pooling on the ice ceilings above. They mix up the physical states of solid, liquid, and gas, affecting the visuality of the documentary.

A traditional way to understand media and environment, here, would be to simply say that *Voyage to the Edge of the World* is a documentary film about the Antarctic Ocean. Film is the medium, and it represents an underwater scene as visual fantasy. However, one of the key questions that media scholar John Durham Peters raises in his book *The Marvelous Clouds* (2015) is whether the ocean is also a medium. In one sense we might think of the ocean as an anti-medium, if we

consider how it damages particular kinds of anthropogenic media like books, film, and unprotected electronics through the corrosions of saltwater. Yet in another sense, Peters writes, "the ocean is the medium of all media, the fountain from which all life on earth emerged."[2] Here Peters draws on a biological sense of medium, like agar that helps culture bacteria in a Petri dish. Yet the ocean can also be a visual medium, sculptural medium, informatic medium, and more—conditions which depend upon who, or what apparatus, is doing the observing.

BUBBLES AS VISUAL MEDIA

In *Voyage to the Edge of the World*, oceanic bubbles *are* visual media that participate in the aesthetics of the film. For example, during the sequence Philippe Cousteau narrates, small bubbles often collect on the lens of the camera itself, and sometimes the cascading exhalations of divers obscure the camera's ability to see through clear water. This produces what Bridget Crone calls a "turbid image," where the "density of matter suspended in water produces its own image (or turbid-image)."[3] The matter need not only be solid particles, but can also be created by the ephemeral passing of air bubbles that interfere with the clarity in recorded scene. Underwater, the bubbles also create new reflective surfaces. As the divers explore the iceberg's underbelly, their air bubbles often collide, pooling beneath ceilings of ice. This has the effect of creating a new pocket of air, and from the camera's perspective (perhaps 10 or 20 feet away) appears a silvery, reflective mirror surface → FIG. X. To observe something in person we sometimes change it. Such is the case here: not only are the natural surfaces of ice able to reflect light, or the warm glow of the divers' red suits—the divers' own exhalations create pools to mirror their reflection back to the camera. Underwater, breath itself participates in the formation of the cinematic image.

FIG. X A ceiling of exhaled air reflects the diver's image underneath an iceberg. Still image from *Voyage to the Edge of the World*, 1976, directed by Jacques Cousteau, Philippe Cousteau, and Marshall Flaum.

The cinematic image also depends on the buoyancy of the ocean within which the divers swim. As Margaret Cohen observes in her book *The Underwater Eye: How the Movie Camera Opened the Depths and Unleashed New Realms of Fantasy* (2022), underwater cameras are able to smoothly pan when neutrally buoyant within the medium of seawater. Cohen writes that with film, "the medium fits the message" because moving imagery has the capacity to convey the unique submarine conditions "such as the glide of movement and the disorienting perception of underwater space."[4] On land, this same effect of smoothness would require special rigs to hold and move the camera. These terrestrial technologies are substitutes, then, for the cinematic effects of movement that are naturally possible within the ocean. Such fluid possibilities of movement are also what Cohen attributes to underwater cinema's gothic aesthetics, where the camera (via a swimming diver) may approach an underwater wreck diagonally via a Dutch angle or canted shot.[5] Similarly, Philippe Cousteau describes the underwater iceberg as a gothic space: like an empty house that occasionally creaks with the sounds of internal stress and fracture, the iceberg always presents the danger of possible collapse, and a number of camera shots dizzyingly spiral with the movements of the swimming diver.

BUBBLES AS CLIMATE DATA

We can also think about ocean media as those elements of the ocean that perform a technical function, such as when bubbles become informatic media. For example, Philippe imagines that, back when the iceberg was still part of a continental glacier, "every storm, every winter and summer, was engraved in its heart." The unspoken analogy is this: the bubbles are a kind of climate writing that was engraved in the icy book of the glacier. The ice is informatically valuable, or bookish, because of its air bubbles—although the process of scientifically analyzing the air bubbles involves melting (destroying) entire ice cores in order to release them and read their chemical composition. Bubbles are informational media when they are seen to record history, where scientific analysis of their elemental composition provides clues about earlier climates.[6] A variation is operative in Roni Horn's art exhibit *Vatnasafn/Library of Water* (2007), which features pillars of melted ice from twenty-four glaciers; here, emphasis is on each water sample as a kind of book in the larger library. Yet regardless of the medium of recording (air, liquid, or ice), what matters is the way its physical presence attests to a kind of historical witnessing of past climates, or what some would call its indexicality.

BUBBLES, ICE, AND WATER AS EXTENSIONS OF GLASS

The elements of seawater, bubbles, and ice are also media through the material way that they extend the glass of the camera lens itself; just as light filters through clear glass, so it continues through the transparent media of tropical waters and crystalline ice. This is not merely an analogy, but a matter of technical function. As Ann Elias writes, the Caribbean and Pacific were attractive environments for photographers like John Williamson and Frank Hurley because of the clarity of the water. In addition, the corals themselves were photosensitive: "there was a magical correspondence in the way the natural phenomenon of corals and the technological processes of photographs both required light for photochemical reactions. It was a revelation that corals, as well as photographs, needed light to bring them to life and enable development" (Elias 2018, 20). Sometimes Williamson and Hurley, like French filmmaker and photographer Jean Painlevé, used aquariums to assist their photographic capture of sea creatures—an artificial environment in which the aquarium glass augmented the camera's focusing lens by adding a slight magnification. The Antarctic Ocean provides similar conditions of clarity in *Voyage to the Edge of the World*, where the camera often peers through glass-like structures of ice and seawater → FIG. Y. The materiality of the camera lens finds its double in all three phases of matter through which light passes: air, liquid water, and solid ice.

FIG. Y Underwater iceberg. Still image from *Voyage to the Edge of the World*, 1976, directed by Jacques Cousteau, Philippe Cousteau, and Marshall Flaum.

Glass is also an optical extension of photographic documentation in Toril Johannesen's and Marjolijn Dijkman's, *Liquid Properties* (2018) → FIG. 38. In this work, glass bubbles enclose small micro-ecologies of water and algae, suspended by a metal framework of posts and clamps—like circular vials in a scientific laboratory, proliferated and akilter. The glass figures are described as reminiscent of "lab equipment glassware, buoys, ecospheres and water lenses."[7] Indeed in a lens-like way,

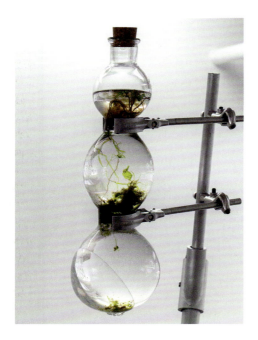

FIG. Z Detail of Toril Johannesen and Marjolijn Dijkman, *Liquid Properties*, 2018. Courtesy the artists and OSL Contemporary.

the glass bubbles are sealed with a cork but are transparent, allowing light (but not water) to pass through. There is a scopophilic temptation at play with both these bubbles and the viewfinder of a camera, where one feels compelled to approach up close and gaze inside. The glass bubbles and the glass viewfinder are magnifying and focalizing media that enclose and enframe pockets of life → FIG. Z.

Liquid Properties and *Voyage to the Edge of the World* both draw attention to the three-dimensionality of bubbles as media, and how they may be altered through the photographic capture of two-dimensional media like photography and film. Whereas *Voyage to the Edge of the World* captures the sculptural contours of the iceberg via the flat medium of film, *Liquid Properties* is, itself, sculpture; and whereas the iceberg in *Voyage* is melting and changing all the time, the glass bubbles in *Liquid Properties* are still (as if frozen) even as their encapsulated ecologies grow and change. Film theorist Peter Wollen once wrote a short essay in which he compared visual media to the elements: film was like fire, flickering and in movement, while photography was like ice—frozen and still.[8] Yet Wollen's analogy doesn't quite work with either *Liquid Properties* or *Voyage to the Edge of the World*. In *Liquid Properties*, the sculptures contain microecologies that are enclosed (suggesting that the sculpture is like photography, a still version of a three-dimensional subject), but whose insides are changing all the time (suggesting that the enclosed water is flickering like film, but slowly).

BUBBLES AS MIXED ELEMENTAL MEDIA

In *Voyage to the Edge of the World*, both elements and media are mixed. Swimming over one dappled surface under the iceberg, Philippe Cousteau narrates: "everything here is made of air and water; water liquid, water solid, water pure, and water mixed with air; air that is trapped in microscopic bubbles." Describing another surface, he notice that "the ice filled with small air bubbles is smooth and bright. It was the encounter of freshwater ice and salted seawater that created this improbable surface." The "improbable surface" mixes the elements: gas bubbles are trapped within a solid, while the melting of the solid has been shaped by the contact between two different kinds of water. It would be inaccurate to say that the iceberg is separate from the sea, or the atmosphere; rather, the elements are intimately folded within each other. We might also say the same of media: the technology of the camera is not alone and separate, but is co-extended through the lens-like transparency of seawater and ice, along with the reflective surfaces of air pockets from the divers' exhalations.

I have given consideration, so far, to the ways that ocean media (water, ice, bubbles) are functionally similar to visual technologies, like the camera, and the ways in which they contribute to the cinematic aesthetics of *Voyage to the Edge of the World*. However, there is one other perspective on ocean media we might address, which I raise in *Wild Blue Media: Thinking Through Seawater* (2020): what happens when terrestrial modes of media description are applied to our understanding of water? To what extent does as a terrestrial bias influence the way that we understand the ocean, and the ocean as medium?

WHAT DO UNDERWATER BUBBLES RECORD?

To return to *Voyage to the Edge of the World*, consider how Philippe Cousteau describes how "every storm, every winter and summer" was "engraved" in the heart of the iceberg via tiny trapped bubbles. Here, the verb *engraved* is not consistent with the material described (bubbles trapped in ice). To engrave something is to place a written mark, etching, or cut on a solid surface—perhaps paper (carefully archived) or stone. Are bubbles trapped in ice adrift in the ocean really a kind of engraving from the past? Or is Philippe Cousteau's description a symptom of a broader terrestrial bias towards describing ocean media through the vocabulary of dry, anthropogenic technologies?

 A more speculative approach could be to ask what kind of record is suggested by the poetics of bubbles. Rather than saying such bubbles entrained within ice are analogically "like" a book with two dimensional pages for us to read, perhaps the bubbles offer a wholly other way of thinking about records, media, and where the ocean environment stores history. I wonder about the bubbles as a three-dimensional kind of Braille (or is that another terrestrial analogy?) that seems to invite touch; Philippe narrates, "we cannot help caressing the surfaces that dazzlingly reflect our lights," even as the divers float suspended in a mixture of the iceberg's meltwater and saltwater. Perhaps the key verb here is *suspension*, of the bubbles in ice, and the divers witnessing it within seawater.

WHAT BUBBLES LEAVE BEHIND

Bubbles are vital media, like those glass structures in *Liquid Properties* that encase microecologies—but they can also be harbingers of environmental damage. Consider one final moment of suspension of bodies and bubbles: when Philippe Cousteau narrates that the divers "leave behind the cascading echoes of our bubbles within the palace of ice," we might think first of ephemerality, of the short-lived echoes of the divers' exhalations reverberating for a brief moment through a labyrinth of ice under the sea. It is a moment that shifts our sense of the bubble's ephemerality from a visual and tactile register (bursting) to an acoustic one (echoing). However, this moment may also be read as a moment of visual metonymy, if we consider the materiality of what the divers are leaving behind: as with all human breath, their exhalations are carbon dioxide. To see, on screen, the divers leaving behind bubbles of carbon dioxide is a visual reminder of broader societal exhalations that accumulate in the atmosphere, and ocean—acidifying it and destroying shelled-sea creatures.[9] Breath not only participates in the formation of the cinematic image; it also participates, at however small a scale, in the changing of the climate.

Endnotes

1 Peter Sloterdjik, *Bubbles*. Cambridge: Semiotexte, 2011.
2 John Durham Peters, *The Marvelous Clouds: Towards a Philosophy of Elemental Media*. Chicago: University of Chicago Press, 2015, p. 54.
3 Bridget Crone, "Turbid Images," in *Experimental Fieldwork for Future Ecologies: Radical Practice for Art and Art-based Research*. Eindhoven: Onomatopee, 2023, pp. 492–493.
4 Margaret Cohen, *The Underwater Eye: How the Movie Camera Opened the Depths and Unleashed New Realms of Fantasy*. Princeton: Princeton University Press, 2022, p. 7.
5 Ibid., p. 122.
6 Melody Jue and Rafico Ruiz, "Time is Melting: Glaciers and the Amplification of Climate Change," in *Resilience: A Journal of the Environmental Humanities* 7.2/7.3 (May 2020), pp. 178–199.
7 https://www.toriljohannessen.no/works/liquid-properties/ (accessed 10 January 2024).
8 Peter Wollen, "Fire and Ice," in Liz Wells (ed.), *The Photography Reader*. New York: Routledge, 2002, pp. 76–80.
9 Stacy Alaimo, *Exposed: Environmental Politics and Pleasures in Posthuman Times*. Minneapolis: Minnesota, 2016.

OLAUS MAGNUS
GERARD MERCATOR
CHARLES LOUIS MOZIN &
AUGUSTE ETIENNE FRANÇOIS MAYER
ELINE MUGAAS
EDVARD MUNCH
JOAR NANGO
ROLF NESCH
ABRAHAM ORTELIUS
TREVOR PAGLEN
JEAN PAINLEVÉ
SONDRA PERRY
ERIK PONTOPPIDAN
AXEL REVOLD
LÉON SABATIER
ALLAN SEKULA
FIN SERCK-HANSSEN
ANDERS FREDRIK SKJÖLDEBRAND
JOSEPH MALLORD WILLIAM TURNER
SUSANNE M. WINTERLING
DAVID ZINK YI

WORKS

WMRZ

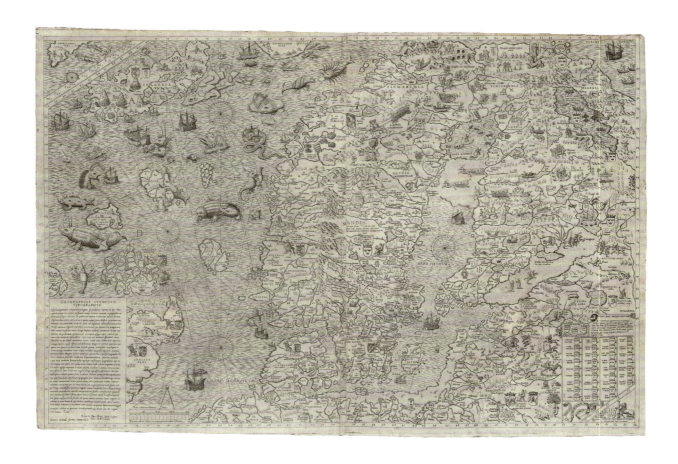

FIG. 71 *Carta Marina*, 1572, 1602 version
Copperplate engraving on paper
Nasjonalbiblioteket, Oslo
Photo: Nasjonalbiblioteket

OLAUS MAGNUS

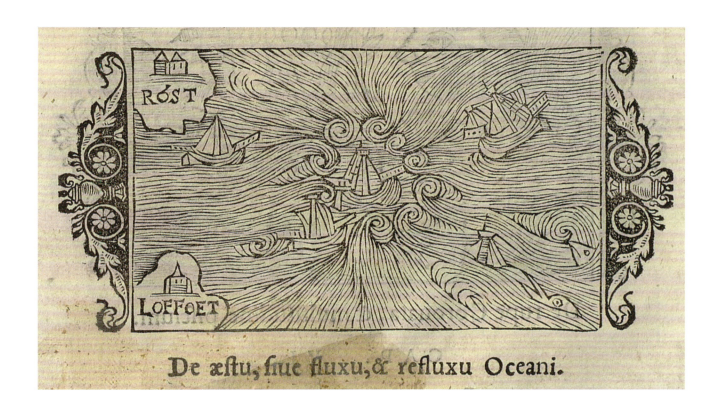

FIG. 72 *The Maelstrom outside of Lofoten*, from *Historia de gentibus septentrionalibus* (*The History of the Nordic People*), 1555
Woodcut on paper
Nasjonalbiblioteket, Oslo
Photo: Nasjonalbiblioteket

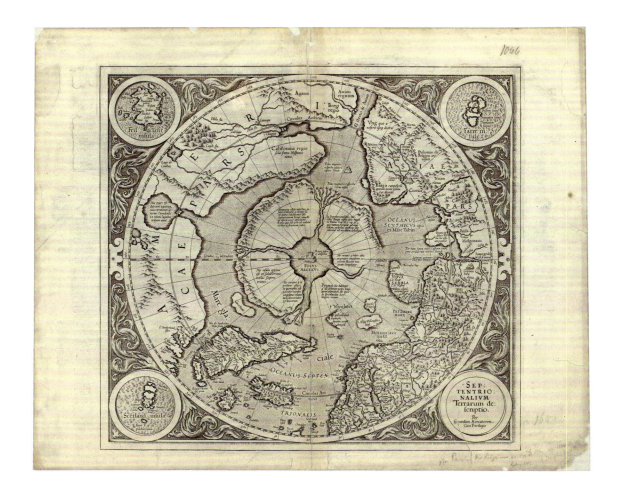

FIG. 73 *Septentrionalium Terrarum descriptio, Map of the Arctic, with four Islands;*
state 2 including Svalbard and Bjørnøya, ca. 1630
Copperplate engraving on paper
Nasjonalbiblioteket, Oslo
Photo: Nasjonalbiblioteket

CHARLES LOUIS MOZIN & AUGUSTE ETIENNE FRANÇOIS MAYER

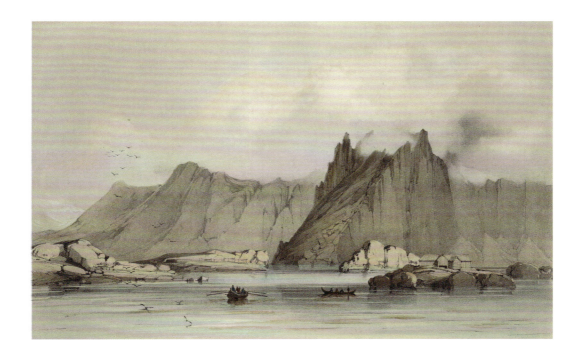

FIG. 74 *Fishermen in Lofoten*, between 1842 and 1856
Hand-colored litograph on paper
Nasjonalmuseet for kunst, arkitektur og design, Oslo
Photo: Nasjonalmuseet/Andreas Harvik

FIGS. 75–78 *Oil tankers I–IV*, 2006
Archival inkjet print
Courtesy the artist and Galleri Riis
© Eline Mugaas/BONO 2024

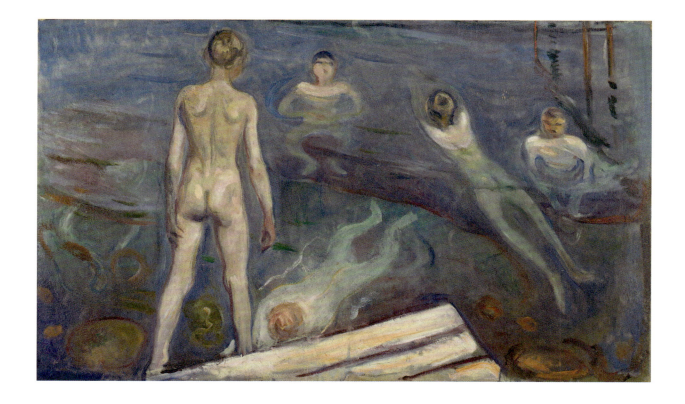

FIG. 79 *Bathing Boys*, 1894
Oil on canvas
Nasjonalmuseet for kunst, arkitektur og design, Oslo
Photo: Nasjonalmuseet/Børre Høstland

JOAR NANGO

FIGS. 80-81 *Skievvar*, 2019–, installed for Festspillutstillingen at Bergen Kunsthall, 2020
Dried halibut stomach skin, tendon thread, wood, video with sound
Video: Markus Gavin, sound: Alexander Rishaug
Henie Cnstad Kunstsenter, Høvikodden
Photo: Bergen Kunsthall/Thor Brødreskift

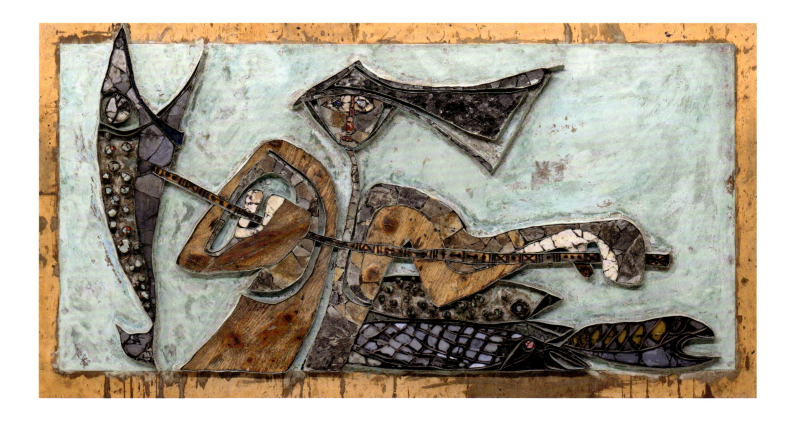

FIG. 82 *Fisherman in Lofoten with his Catch*, ca. 1970
Material work (metal, glass, wood, copper)
Nordnorsk Kunstmuseum, Tromsø
Photo: Nordnorsk Kunstmuseum/Kim G. Skytte
© Rolf Nesch/BONO 2024

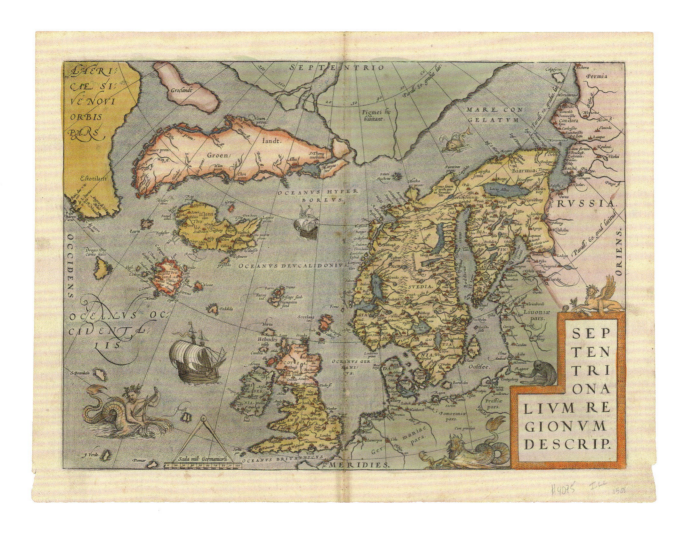

FIG. 83 *Septentrionalium regionum descrip*, 1575, from *Theatrum orbis terrarum*
Copperplate engraving on paper, hand-colored
Nasjonalbiblioteket, Oslo
Photo: Nasjonalbiblioteket

FIG. 84 *Globenet NSA/GCHQ-Tapped Undersea Cable Atlantic Ocean*, 2015
C-Print
Courtesy the artist, Altman Siegel, San Francisco and Pace Gallery
© Trevor Paglen

FIG. 85 *Bahamas Internet Cable System (BICS-1) NSA/GCHQ-Tapped Undersea Cable Atlantic Ocean*, 2015
C-Print
Courtesy the artist, Altman Siegel, San Francisco and Pace Gallery
© Trevor Paglen

FIG. 86 *Octopus Tentacles*, 1928
Silver gelatine print
Courtesy Archives Jean Painlevé/
Les Documents cinématographiques, Paris
© Jean Painlevé/BONO 2024

FIG. 87 *Seahorse Bust*, 1931
Silver gelatine print
Courtesy Archives Jean Painlevé/
Les Documents cinématographiques, Paris
© Jean Painlevé/BONO 2024

FIGS. 88–89 *Wet and Wavy Looks — Typhoon coming on
for a Three Monitor Workstation*, 2016
Video, rowing machine workstation, Eco styler gel
Courtesy Bridget Donahue, New York
Photo: Jason Mandella

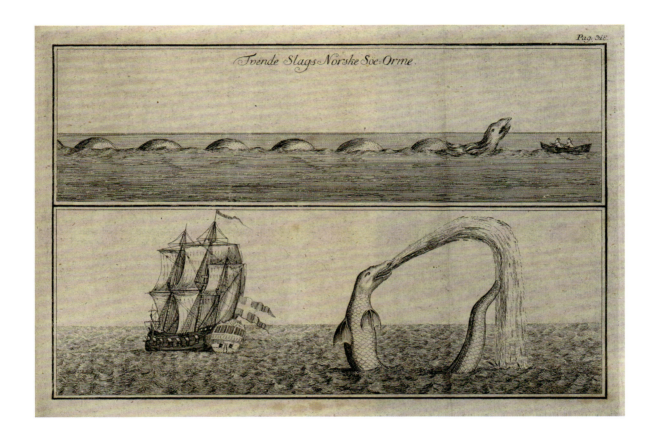

FIG. 90 *Two Species of Norwegian Sea Serpents*, 1752–53
From *The Natural History of Norway*
Copperplate engraving on paper
Nasjonalbiblioteket, Oslo
Photo: Nasjonalbiblioteket

FIG. 91 *The Fishing Fleet Leaves the Harbour*, 1935
Oil on canvas
Nasjonalmuseet for kunst, arkitektur og design, Oslo
Photo: Nasjonalmuseet/Børre Høstland
© Axel Revold/BONO 2024

FIG. 92 *Aurora Borealis, at Bossekop, (Finnmark), December 30th 1838 at 20h 32m*, published 1852
Litograph on paper
Nordnorsk Kunstmuseum, Tromsø
Photo: Nordnorsk Kunstmuseum

LÉON SABATIER

FIG. 93 *Aurora Borealis in Kaafjord, (Finnmark),
 January 24th 1839 at 19h 25m*, published 1852
 Litograph on paper
 Nordnorsk Kunstmuseum, Tromsø
 Photo: Nordnorsk Kunstmuseum

FIG. 94 *Boy looking at his mother. Staten Island Ferry. New York Harbour* of the whole *Fish Story (Chapter 1, Fish Story)*, February 1990

All works from *Fish Story (Chapter 1, Fish Story)*
Cibachrome
Frac Bretagne Collection © The Estate of Allan Sekula
Photo: Frac Bretagne

FIG. 95 *Boy looking at his mother. Staten Island Ferry. New York Harbour* of the whole *Fish Story (Chapter 1, Fish Story)*, February 1990

FIG. 96 *Shipyard-workers' housing—built during World War - II—being moved from San Pedro to south-central Los Angeles* of the whole *Fish Story (Chapter 1, Fish Story)*, May 1990

FIG. 97 *Pipe fitters finishing the engine room of a tuna fishing boat. Campbell Shipyard. San Diego Harbour* of the whole *Fish Story (Chapter 1, Fish Story)*, August 1991

FIG. 98 *The rechristened Exxon Waldez awaiting sea trials after repairs. National Steel and Shipbuilding Company. San Diego harbour* of the whole *Fish Story (Chapter 1, Fish Story)*, August 1990

FIG. 99 *Hammerhead crane unloading forty-foot containers from Asian ports. American President Lines terminal. Los Angeles harbour. San Pedro, California* of the whole *Fish Story (Chapter 1, Fish Story)*, November 1992

FIG. 100 *Abandoned shipyard used by Marine Corps Expeditionary Force for "counter-terrorist" exercises. Los Angeles harbour. Terminal Island, California* of the whole *Fish Story (Chapter 1, Fish Story)*, November 1992

FIG. 101 *Pioneer Divers from the North Sea, Inge Eriksen*, 2006
Silver gelatin print
Courtesy the artist
© Fin Serck-Hanssen/BONO 2024

FIG. 102 *Pioneer Divers from the North Sea, Tom Engh*, 2006
Silver gelatin print
Courtesy the artist
© Fin Serck-Hanssen/BONO 2024

FIG. 103 *The North Cape in Midnight Sun*, 1801–02

FIG. 104 *Rocks Along the Coast of the Ice Sea*, 1801–02

ANDERS FREDRIK SKJÖLDEBRAND

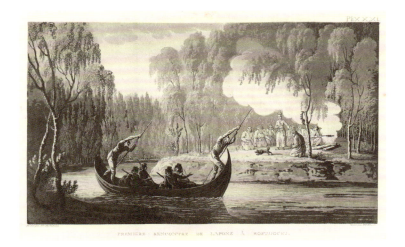 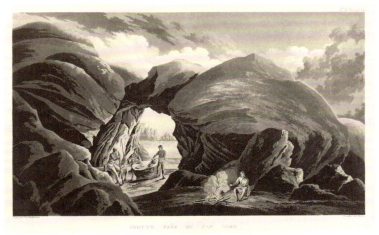

FIG. 105 *The First Encounter with the Sámi People of Rastajok¹, Finland,* 1801–02

FIG. 106 *Travellers Resting in a Grotto Close to the North Cape,* 1801–02

Litographs from *Voyage Pittoresque au Cap Nord*, 1801–02
Norsk Kultursenter, Koppang
Photo: Nasjonalmuseet for kunst, arkitektur og design, Oslo

FIG. 107 *Seascape*, 1828
Oil paint on millboard
Tate Britain, London
Accepted by the nation as part of the Turner Bequest 1856
Photo: Tate

JOSEPH MALLORD WILLIAM TURNER

FIG. 108 *Study of Sea: Stormy Sky*, 1775–1851
Watercolor on paper
Victoria and Albert Museum, London
© Victoria and Albert Museum, London

FIG. 109 From *gravitational currents and the magic of life: shield warrior for biodiversity and meditation on terraforming (a tribute to Marie Tharp)*, 2018
Local fishingnet, bioresin casts, sand cast
Courtesy the artist and Empty Gallery, Hong Kong
Photo: Michael Yu
© VG BildKunst, Susanne M. Winterling/BONO 2024

FIG. 110 *Untitled (Architeuthis)*, 2010
Burnt and glazed clay
Courtesy the artist and Hauser & Wirth
Photo: Stefan Altenburger Photography Zürich
© David Zink Yi

CONTRIBUTOR BIOGRAPHIES

Dr. **Camilla Brattland** is from Gáivuotna-Kåfjord, a Sámi coastal community in northern Norway. She focused her doctoral research on mapping and governance of Sámi seascapes and has since specialized in the intersection between marine science and traditional knowledge. She currently holds an associate professor position in Sámi cultural science at the Norwegian Arctic University Museum in Tromsø (UiT), Norway, where she works with the Sámi archives and collections and coastal Sámi history and culture. Her research projects center on participatory mapping and use of Indigenous and local ecological knowledge in marine conservation and management, as well as Indigenous knowledge and understandings of seascapes and their nature rights.

Stefanie Hessler is the Director of Swiss Institute (SI) in New York. At SI, Hessler has co-curated exhibitions by Ali Cherri, Lap-See Lam, and Raven Chacon, and initiated the curatorial initiative *Spora*, which invites artists to transform the institution through what she calls "environmental institutional critique." Previously, as the Director of Kunsthall Trondheim in Norway, Hessler co-led among others the exhibition *Sex Ecologies* and edited the accompanying compendium on queer ecologies, sexuality, and care in more-than-human worlds. Hessler is the author of *Prospecting Ocean* (MIT Press, 2019), and has edited over a dozen volumes. She is a founding committee member of the New York chapter of the Gallery Climate Coalition (GCC).

Dr. **Melody Jue** is Associate Professor of English at the University of California, Santa Barbara, working across the fields of ocean humanities, science fiction, science studies, and media theory. She is the author of *Wild Blue Media: Thinking Through Seawater* (Duke University Press, 2020), which won the 2020 Speculative Fictions and Cultures of Science book award. She is the co-editor with Rafico Ruiz of *Saturation* (Duke University, 2021) and co-editor with Zach Blas and Jennifer Rhee of *Informatics of Domination* (Duke University Press, under contract).

Professor Jue has published articles in journals including *Grey Room*, *Configurations*, *Women's Studies Quarterly*, *Resilience*, and *Media+Environment*. Her new work explores the mediations of seaweeds in trans-Pacific contexts.

Dr. **Knut Ljøgodt** is a Norwegian art historian, presently Director of Nordic Institute of Art, Oslo. He has previously been a Curator in the National Gallery, Oslo, Director of Northern Norway Art Museum, Tromsø, as well as Founding Director of Kunsthall Svalbard, Longyearbyen. Ljøgodt has curated/co-curated exhibitions such as *David Hockney: Northern Landscapes*, Northern Norway Art Museum 2012; *Peder Balke*, National Gallery, London 2014-15; *Histories: Three Generations Sámi Artists*, Queen Sonja Gallery, Oslo 2019; *Visionary Romantics*, Museo Lázaro Galdiano, Madrid & Stavanger Art Museum 2023. He is the author/co-author of *Knud Baade: Moonlight Romantic/Måneskinnsmaleren* (Orkana 2012); *Sverre Bjertnæs* (Arnoldsche 2019); *Peder Balke: Sublime North* (Skira 2020) and several other publications.

Dr. **Martin Olin**, art historian, is the Director of Collections at Nationalmuseum, Stockholm, an Associate Professor of art history as well as an Associate Fellow of the Nordic Institute of Art. His research has focused on art and architecture in the late 17th century, in particular the works and drawings collection of Nicodemus Tessin the Younger, as well as on painting and historiography in Scandinavia during the 19th century. Olin served as Deputy Director of the Swedish Institute in Rome 2013–15. He has curated several exhibitions at the Nationalmuseum, such as *Carl Larsson: Friends and Enemies* (2013) and *Arcadia – A Paradise Lost*, on Italian and French landscape painting in the classical tradition (2020).

Dr. **Patrik Steorn** is an art historian and director of Gothenburg's Art Museum. He is the former director of Thielska Galleriet in Stockholm. His doctoral thesis from Stockholm University, *Nakna Män: Masculinitet och kreativität i svensk bildkultur 1900-1915* (published in book form, Norstedts Akademiska Förlag, 2006), was a pioneering work in LGBTQ research in art history. Steorn has also curated several exhibitions and has published extensively on LGBTQ topics, with an emphasis on Nordic art from the late 19th and early 20th centuries. Among his publications is "Sjömannen i konsten: Kroppen, kläder och homoerotik" in *Marinmålarna: Havet, skeppet och sjömannen i konsten* (Sjöhistoriska Museet & Historiska Media, Stockholm 2020).

Ove Stødle is from Billávuotna in Porsanger, where he grew up in a Sámi coastal community. Since 2021 he is the head of the Sámi coastal institution, Mearrasiida, that works with preserving, strengthening and revitalizing coastal Sámi traditions and knowledge in Porsanger and Finnmark. Mearrasiida is also a research partner in various projects regarding safeguarding and mapping of Indigenous knowledge in the Porsangerfjord. Stødle is also a *duojár* (Sámi artisan) that works with traditional materials such as reindeer antlers and wood, and has learned building traditional Sea Sámi wooden boats.

This catalogue is published on the occasion of the exhibition
The Atlantic Ocean. Myths, Art, Science
Henie Onstad Kunstsenter
26 April—15 September 2024

Cover image: Per Krohg: *Malstrømmen/The Maelstrom*, 1929 (detail)
© Per Krohg/BONO 2024

Editors: Susanne Østby Sæther, Stefanie Hessler, and Knut Ljøgodt
Editorial Coordination: Emma Cavazzini
Copy Editing: Andrew Ellis
Translations: Gabriella Berggren
Iconographic Research: Martine Hoff Jensen
Design: Håkon Stensholt/ANTI
Typeface: Post Grotesk by Josh Finklea, Sharp Type
Paper: Magno Volume 150gr

First published in Italy in 2024 by
Skira editore S.p.A.
Palazzo Casati Stampa
via Torino 61
20123 Milano
Italy
www.skira.net

© 2024 Henie Onstad Kunstsenter
© 2024 Skira editore

All rights reserved under international copyright conventions. No part of this book may be reproduced or utilized in any form or by any means, electronic or mechanical, including photocopying, recording, or any information storage and retrieval system, without permission in writing from the publisher.

Printed and bound in Italy. First edition
ISBN: 978-82-8294-044-3 (Henie Onstad Kunstsenter)
ISBN: 978-88-572-5223-0 (Skira editore)

Distributed in USA, Canada, Central & South America by ARTBOOK | D.A.P.,
75 Broad Street, Suite 630, New York, NY 10004, USA.
Distributed elsewhere in the world by Thames and Hudson Ltd.,
181A High Holborn, London WC1V 7QX, United Kingdom.

The exhibition is supported by DNV, Nadia og Jacob Stolt-Nielsen Veldedige Stiftelse, Formue, Blystad Group, Clarksons, Viking, Bergesenstiftelsen, and Fritt Ord.